THE PHOTOGRAPH AND THE AMERICAN DREAM 1840-1940

VAN GOGH MUSEUM AMSTERDAM

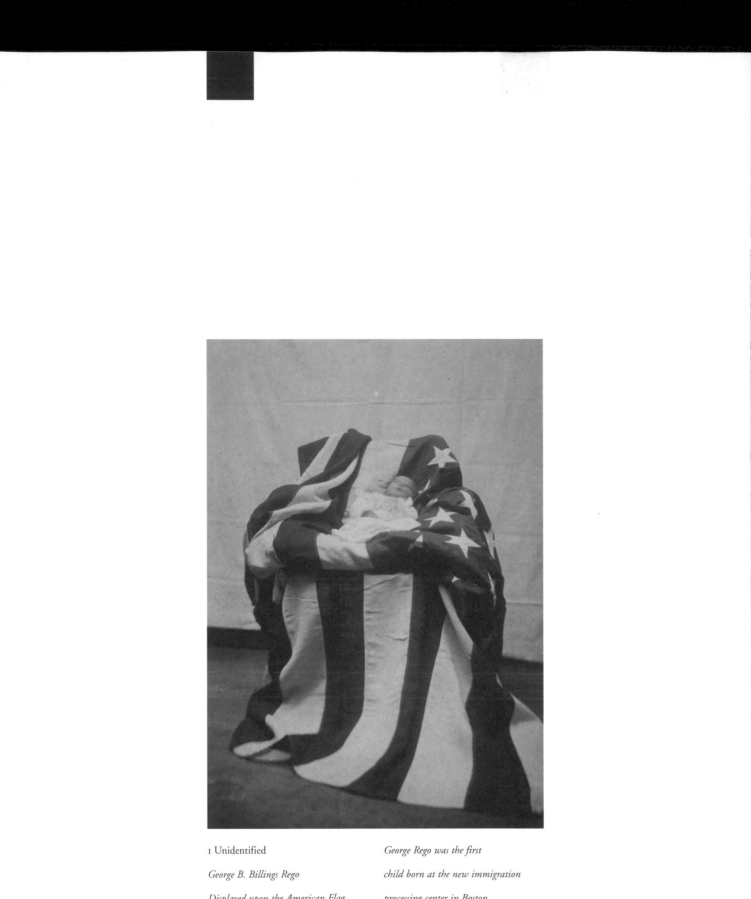

1 Unidentified

George B. Billings Rego

Displayed upon the American Flag

Boston, Massachusetts

circa 1900

cyanotype print

10.8 x 7.6 cm (4¼ x 3")

George Rego was the first

child born at the new immigration

processing center in Boston.

He was named after the director

by his Portuguese immigrant parents.

THE PHOTOGRAPH AND THE AMERICAN DREAM 1840-1940

VAN GOGH MUSEUM AMSTERDAM

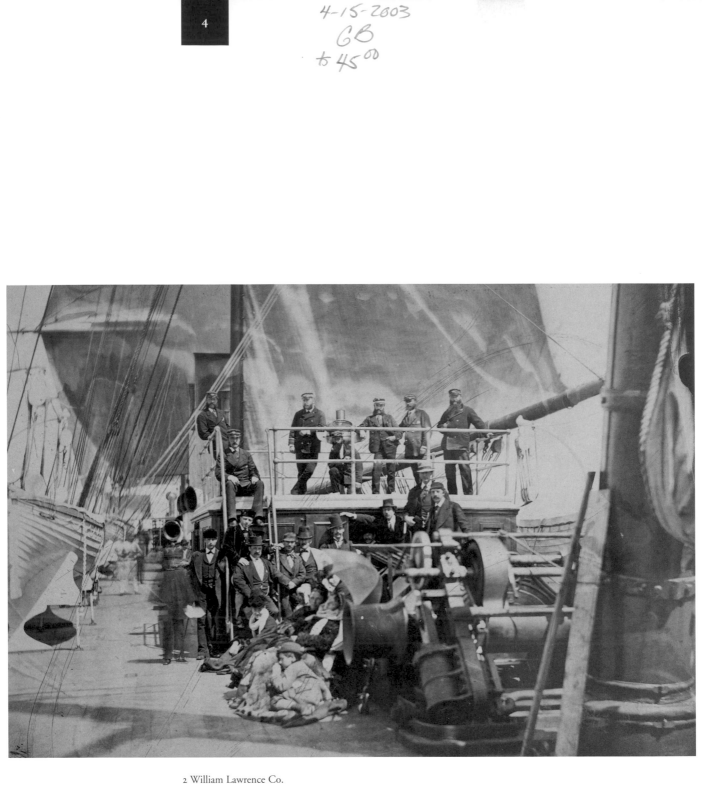

2 William Lawrence Co.

(Robert French)

Emigrants Leaving for the United States

Dublin, Ireland

1874

albumen print

14 x 20.3 cm (5½ x 8")

TABLE
OF
CONTENTS

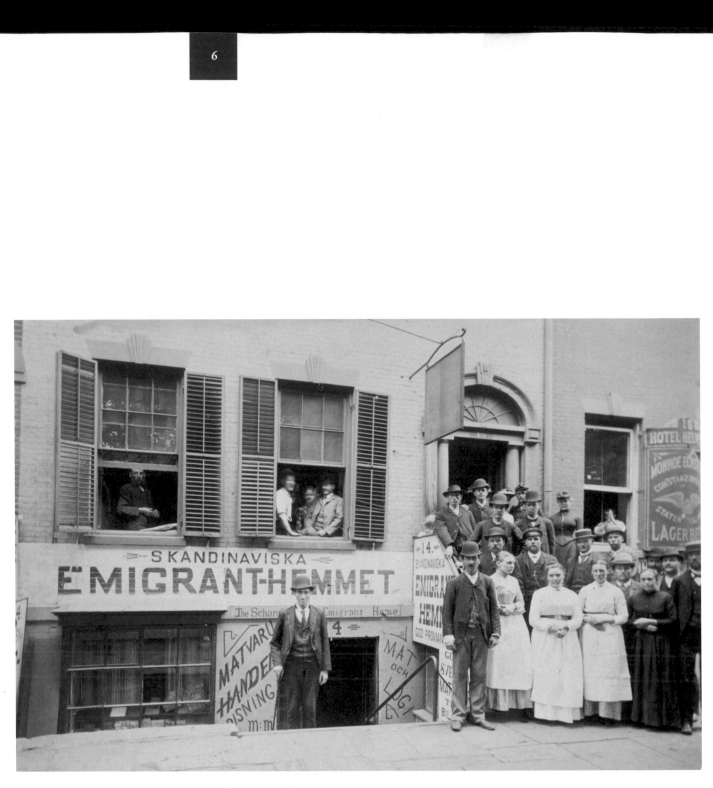

3 Photo View Co.

Immigrant House for Scandinavians

New York City

circa 1890

albumen print

13.7 x 20.6 cm (5⅜ x 8⅛")

ACKNOWLEDGEMENTS

A moment can stretch as far as a lifetime with the proper luck. One day in 1997, while visiting Brussels, I stopped off to see my friends, the Oleffs, as I do each time I am there, for they have one of the finest art book shops in Europe. Oleff, being a generous man, introduced me to a curator visiting the shop at the same time, Edwin Becker of the Van Gogh Museum.

"Too bad you don't do photographic exhibitions," I quipped. "Perhaps we will," he responded. "What do you have in mind?"

From that brief exchange an idea was born. I did not have anything specific in mind just yet, but within a few months I could send him a proposal for an exhibition that had been germinating ever since the day I had purchased a beautiful full-plate daguerreotype of the Cleveland family from a friend in New York. That had set me thinking about America, the American identity, how the Cleveland family demonstrated they had achieved the American dream just by having a large photograph taken by one of the great New York photographers, Jeremiah Gurney.

In January, 1999, the director and several curators from the Van Gogh Museum visited Los Angeles for the opening of the exhibition *Van Gogh's Van Goghs* at the Los Angeles County Museum of Art.

Their Head of Exhibitions, Andreas Blühm, visited our house along with his wife Rachel to look at the collection. Much to my delight, Andreas showed great enthusiasm for the idea, and great pleasure in seeing the photographs themselves. Though he had a new building to open within the next few months, he began to formulate a way to exhibit *The Photograph and the American Dream.*

It is to Andreas Blühm I owe the greatest thanks; for his unbridled and unwavering enthusiasm, his wise counsel in the pitfalls of exhibition and catalogue production, for his good humor in the face of adversity, and his desire to move into the great uncharted areas of photography where the richest materials are yet to be mined. John Leighton, director of the museum, has stood solidly behind the project from the beginning. Others on the staff have done their part to ensure the highest professional standards would be maintained, Caroline Breunesse, Aly Noordermeer, Rianne Norbart, Heidi Vandamme, and Sara Verboven.

STEPHEN WHITE

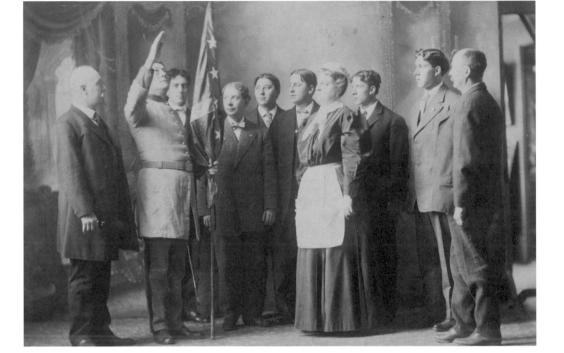

4 Unidentified

New Citizens Taking the Oath

Deadwood, South Dakota

circa 1890

albumen print

11.4 x 17.2 cm (4½ x 6¾")

ACKNOWLEDGEMENTS

For the catalogue we must first thank the former President of the United States, William Jefferson Clinton, who kindly agreed to share with all of us his views on the American dream drawn from his own unique perceptions.

We thank Jim Marrin and Dennis Reed for their design. They have given the catalogue a unique and compelling appearance. They were ably assisted in the production work by Erika Marrin. The book was published under the supervision of Freek Kuin of Calff & Meischke, Amsterdam. Separations were made under the direction of Georges Charlier by Salto in Belgium, and much important advice came from Sue Medlicott.

Many suggestions were offered on the symposium, traveling venues, and catalogue. We would like to thank for their help on the symposium the American Embassy in the Netherlands, specially former Ambassador Cynthia P. Schneider, Tilly de Groot, and Angier Peavy, as well as Marja Roholl and Jaap Verheul of the Netherlands American Studies Association, and Monique Knapen and Anne Wertheim of the John Adams Institute, Amsterdam. For advice and contributions we thank Els Barents, Geoffrey Batchen, Mattie Boom, Denis Canguilhem, Keith Davis, Mick Gidley, Nicholas Goldsborough, Graham Howe and the staff at Curatorial Assistance, Rob Kroes, Alan Trachtenberg, Dennis Waters, and Michael Whalen.

For conservation skills we acknowledge the work of Bob Aitchison and Mark Watters in Los Angeles and Lingbeek & Van Daalen in Amsterdam, Mary Morano for her fine hand in spotting and retouching, the Framing Sisters, Evelien and Wil Hakvoort, for expert matting and framing, and for providing reproductions Ralph Schönbach of the Karl May Gesellschaft, Carole Haensler of the Fondazione Thyssen-Bornemisza, Lugano-Castagnola, and Paul Taylor of the Warburg Institute, University of London.

Finally, we would like to thank our wives and editors, Rachel Esner and Mus White.

ANDREAS BLÜHM
STEPHEN WHITE

FOREWORD

William Jefferson Clinton
42nd President of the
United States of America

I believe in the American Dream. I have lived it. Where else could an ordinary boy from Hope, Arkansas grow up to become President? During the eight years I was privileged to serve as President of the United States, I thought about the American Dream every day. As President I wanted to make sure that everyone had the opportunity to realize his or her potential, to make the most of his or her own life, to live out the American Dream. Even in America, land of opportunity, that has not been easy for many. This is why I am such a strong believer in education. Through education and training, people gain the necessary tools to lead productive lives. I was fortunate to be able to attend excellent schools – Georgetown University, Oxford University, and Yale University Law School – which opened many doors for me. The government cannot deliver the American Dream to its citizens, but it can help them to achieve it for themselves through education and training.

Growing up in the segregated South in Little Rock, Arkansas, I was well aware that not everyone had equal opportunities, although my grandparents and parents always taught me to treat everyone with equal respect. Dr. Martin Luther King articulated the hopes of millions that the American Dream could be a true possibility for all Americans. His dream was a simple one:

I have a dream that one day this nation will rise up and live out the true meaning of its creed: "We hold these truths to be self-evident; that all men are created equal."

I have never forgotten Dr. King's words, nor the courage of others who crusaded for the freedom to strive, the freedom to realize one's potential. I remember the Little Rock Nine, boys and girls who displayed the greatest courage, and for what? The simple right to go to school. I have never forgotten their bravery, nor that of Rosa Parks who defied the authorities for an equally basic right – to sit down on a bus.

Millions today all over the world lack other basic rights – the right to food, shelter, and good health. They dream of simply being able to provide for themselves and their families. In our interdependent world, their problems are our problems. I hope to be able to make a contribution towards solving some of the most difficult problems in the developing world –

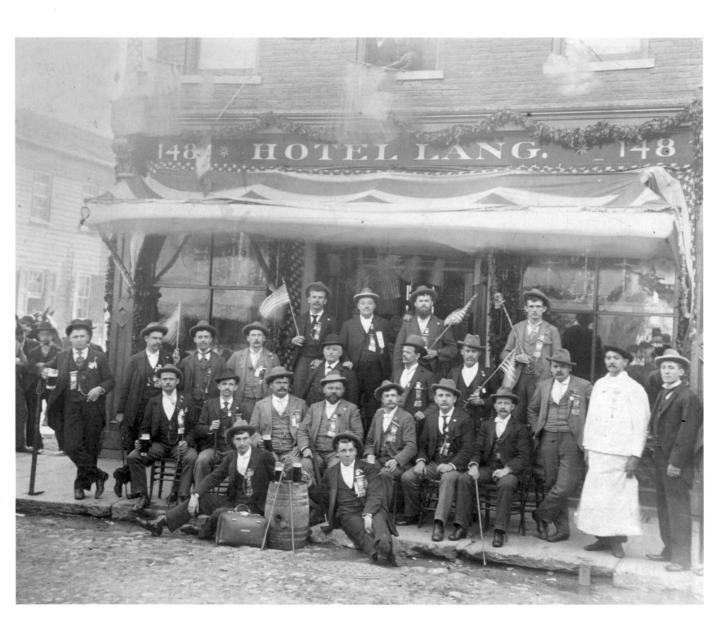

5 Unidentified

28th Songfest, German-Americans

Pittsburgh, Pennsylvania

1896

aristotype print

24.8 x 29.9 cm (9¾ x 11¾")

FOREWORD

William Jefferson Clinton
42nd President of the
United States of America

I believe in the American Dream. I have lived it. Where else could an ordinary boy from Hope, Arkansas grow up to become President? During the eight years I was privileged to serve as President of the United States, I thought about the American Dream every day. As President I wanted to make sure that everyone had the opportunity to realize his or her potential, to make the most of his or her own life, to live out the American Dream. Even in America, land of opportunity, that has not been easy for many. This is why I am such a strong believer in education. Through education and training, people gain the necessary tools to lead productive lives. I was fortunate to be able to attend excellent schools – Georgetown University, Oxford University, and Yale University Law School – which opened many doors for me. The government cannot deliver the American Dream to its citizens, but it can help them to achieve it for themselves through education and training.

Growing up in the segregated South in Little Rock, Arkansas, I was well aware that not everyone had equal opportunities, although my grandparents and parents always taught me to treat everyone with equal respect. Dr. Martin Luther King articulated the hopes of millions that the American Dream could be a true possibility for all Americans. His dream was a simple one:

I have a dream that one day this nation will rise up and live out the true meaning of its creed: "We hold these truths to be self-evident; that all men are created equal."

I have never forgotten Dr. King's words, nor the courage of others who crusaded for the freedom to strive, the freedom to realize one's potential. I remember the Little Rock Nine, boys and girls who displayed the greatest courage, and for what? The simple right to go to school. I have never forgotten their bravery, nor that of Rosa Parks who defied the authorities for an equally basic right – to sit down on a bus.

Millions today all over the world lack other basic rights – the right to food, shelter, and good health. They dream of simply being able to provide for themselves and their families. In our interdependent world, their problems are our problems. I hope to be able to make a contribution towards solving some of the most difficult problems in the developing world –

poverty, hunger, disease, and deprivation of basic human rights. The American Dream is not just for Americans. The fundamental concepts underlying the American Dream – liberty, equal opportunity, equality under the law – should be extended throughout the world.

The moving photographs in this beautiful exhibition chronicle some of the steps along the way to achieving the American Dream. They show us that the journey was not always easy, but nonetheless Americans persevered. I hope that you will derive both pleasure and inspiration from looking at these photographs. Just as the camera captures an unblinking image, so the Americans pictured here face the world and its challenges head on.

Bill Clinton

AMERICAN NOTES

CONCLUDING
REMARKS
Charles Dickens, 1842

They are, by nature, frank, brave, cordial, hospitable, and affectionate. Cultivation and refinement seem to enhance their warmth of heart and ardent enthusiasm; and it is the possession of these latter qualities in a most remarkable degree, which renders an educated American one of the most endearing and most generous of friends. I never was so won upon, as by this class; never yielded up my full confidence and esteem so readily and pleasurably, as to them; never can make again, in half a year, so many friends for whom I seem to entertain the regard of half a life.

These qualities are natural, I implicitly believe, to the whole people. That they are, however, sadly sapped and blighted in their growth among the mass; and that there are influences at work which endanger them still more and give but little present promise of their healthy restoration; is a truth that ought to be told.

It is an essential part of every national character to pique itself mightily upon its faults, and to deduce tokens of its virtue or its wisdom from their very exaggeration. One great blemish in the popular mind of America, and the prolific parent of an innumerable brood of evils, is Universal Distrust...

"You [the American people] carry," says the stranger, "this jealousy and distrust into every transaction of public life. By repelling worthy men from your legislative assemblies, it has bred up a class of candidates for the suffrage, who, in their every act, disgrace your Institutions and your people's choice. It has rendered you so fickle, and so given to change, that your inconstancy has passed into a proverb; for you no sooner set up an idol firmly, than you are sure to pull it down and dash it into fragments; and this because directly you reward a benefactor, or a public servant, you distrust him, merely because he is rewarded; and immediately apply yourselves to find out, either that you have been too bountiful in your acknowledgements, or he remiss in his deserts. Any man who attains a high place among you, from the President downwards, may date his downfall from that moment; for any printed lie that any notorious villain pens, although it militate directly against the character and conduct of a life, appeals at once to your distrust, and is believed..."

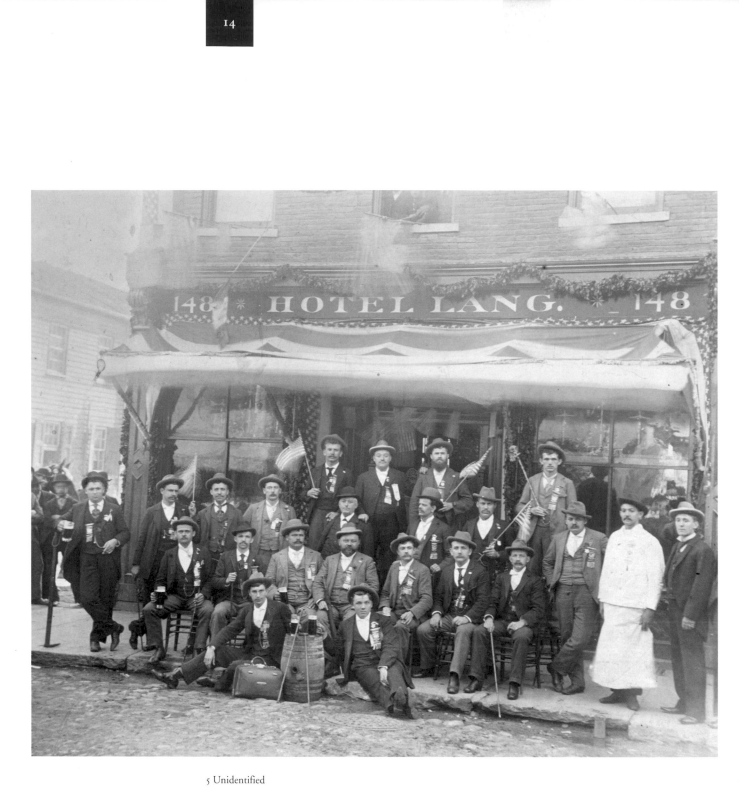

5 Unidentified

28th Songfest, German-Americans

Pittsburgh, Pennsylvania

1896

aristotype print

24.8 x 29.9 cm (9¾ x 11¾")

Another prominent feature is the love of "smart" dealing: which gilds over many a swindle and gross breach of trust; many a defalcation, public and private; and enables many a knave to hold his head up with the best, who well deserves a halter; …

In like manner, all kinds of deficient and impolitic usages are referred to the national love of trade; though, oddly enough, it would be a weighty charge against a foreigner that he regarded the Americans as a trading people. The love of trade is assigned as a reason for that comfortless custom, so very prevalent in country towns, of married persons living in hotels, having no fireside of their own, and seldom meeting from early morning until late at night, but at the hasty public meals. The love of trade is a reason why the literature of America is to remain for ever unprotected: "For we are a trading people, and don't care for poetry:" though we do, by the way, profess to be very proud of our poets:…

Schools may be erected, East, West, North, and South; pupils be taught, and masters reared, by scores upon scores of thousands; colleges may thrive, churches may be crammed, temperance may be diffused, and advancing knowledge in all other forms walk through the land with giant strides; but while the newspaper press of America is in, or near, its present abject state, high moral improvement in that country is hopeless.

There is but one other head on which I wish to offer a remark; and that has reference to the public health. In so vast a country, where there are thousands of millions of acres of land yet unsettled and uncleared, and on every rood of which, vegetable decomposition is annually taking place; where there are so many great rivers, and such opposite varieties of climate; there cannot fail to be a great amount of sickness at certain seasons. But I may venture to say after conversing with many members of the medical profession in America, that much of the disease which does prevail, might be avoided, if a few common precautions were observed. Greater means of personal cleanliness are indispensable to this end; the custom of hastily swallowing large quantities of animal food, three times a-day, and rushing back to sedentary pursuits after each meal, must be changed; the gentler sex must go more wisely clad, and take more healthful exercise; and in the latter cause, the males must be included also.

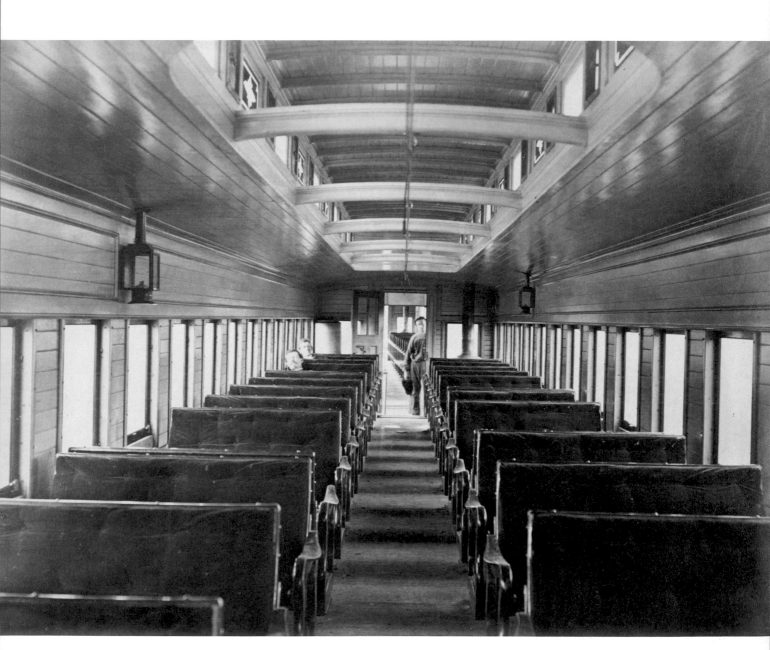

6 William Purviance

Interior, Immigrant Train, between

Philadelphia and Pittsburgh

circa 1875

albumen print

24.8 x 33 cm (9¾ x 13")

The Pennsylvania Railroad

began service between Philadelphia

and Pittsburgh in 1852. Immigrants

could travel by trains from

Pittsburgh into Ohio and other

parts of the Midwest.

POSTSCRIPT

Charles Dickens, May 1868

At a Public Dinner given to me on Saturday the 18th of April, 1868, in the City of New York, by two hundred representatives of the Press of the United States of America, I made the following observations among others:

…I henceforth charge myself, not only here but on every suitable occasion, whatsoever and wheresoever, to express my high and grateful sense of my second reception in America, and to bear my honest testimony to the national generosity and magnanimity. Also, to declare how astounded I have been by the amazing changes I have seen around me on every side,—changes moral, changes, physical, changes in the amount of land subdued and peopled, changes in the rise of vast new cities, changes in the growth of older cities almost out of recognition, changes in the graces and amenities of life, changes in the Press, without whose advancement, no advancement can take place anywhere. Nor am I, believe me, so arrogant as to suppose that in five-and-twenty years there have been no changes in me, and that I had nothing to learn and no extreme impressions to correct when I was here first…

Charles Dickens,
*The Oxford Illustrated
Dickens: American
Notes and Pictures
From Italy* (London:
Oxford University
Press, reprint 1970),
Concluding Remarks:
paragraphs 1, 2, 3
on pp. 244-245,
paragraphs 4, 5 on p.
245, paragraphs 6, 7
on pp. 246-247,
paragraph 8 on p. 251;
Postscript: paragraphs
9, 10 on p.253.

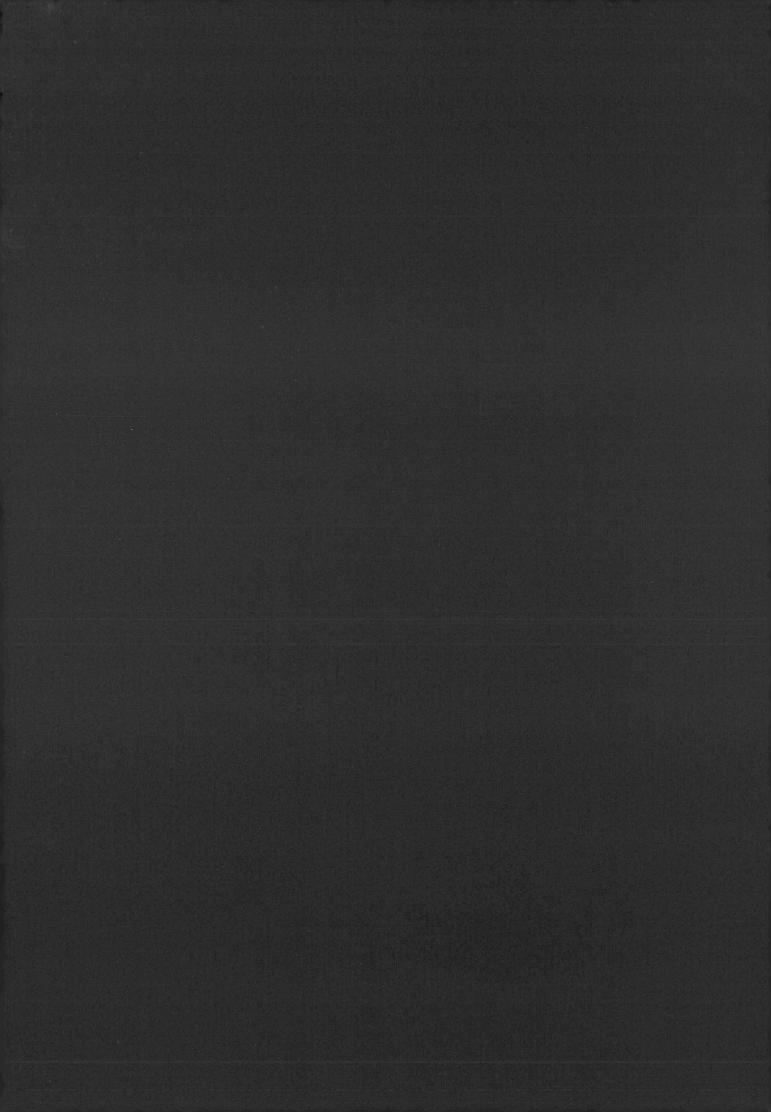

BEAUTIFUL DREAMERS

Stephen White

It takes strong legs to carry the good days.

This curious statement, attributed to yet another "melancholic" Dane, the writer Thorkild Hansen, speaks directly against the grain of American optimism. We have come to believe that fulfilling our dreams will make us better and happier men and women. Nevertheless, if facing failure constitutes a test of our ability to survive hardship, how we handle success is also a measure of our inner strength and moral fiber to sustain our humanity and decency for the long run.

How we as a people have dealt with our failures and our successes over the past couple of hundred years is for the future to evaluate. *The Photograph and the American Dream* is simply a pictorial mirror of our innovative spirit, our courage, our work ethic, our love of play, our land, and our families - as well as a reflection of our greed, our prejudices, and our disastrous missteps. The photographs in the exhibition form a record of how we lived through the bad days and good during the hundred years between 1840 and 1940.

Notwithstanding their function as record keeper, the photographs also signify that our failures and our successes are mandated and predestined by the images themselves. Photographs lured immigrants to our shores, tempted those already here, laid out the path for our "manifest destiny," and broadened our vision of the future. They became our hope and glory - our inspiration.

Theme exhibitions, like *The Photograph and the American Dream,* require that the selection of photographs be driven by the image itself. Consequently, theme-based exhibitions have a way of bringing to light previously unseen photographs by anonymous photographers or unheard-of professionals, as well as works by amateur photographers. The thematic approach, in most ways, runs counter to the development of the history of photography laid out by Alfred Stieglitz and the late art historian Beaumont Newhall who, with his wife Nancy Newhall, codified the field through their classic works, *The History of Photography* and *Masters of Photography.* These works became the blueprint for exhibitions organized by Beaumont Newhall at the Museum of Modern Art and later at the George Eastman House in Rochester, New York.

Newhall saw photography as a pure art form in the hands of the enlightened masters: "In the darkroom these photographers use controls, but only those which enhance conviction, which help convey the truth behind the illusion. This conviction, this truth, is destroyed if negative or print is retouched."[1] One only has to look at today's marketplace to appreciate how well Newhall succeeded in advancing his own conviction of truth. His 1958 book, *Masters of Photography*, has become a bible, so to speak, for collectors to follow. The list of Newhall's masters includes greats such as Ansel Adams, Julia Margaret Cameron, Henri Cartier-Bresson, P. H. Emerson, Edward Steichen, Alfred Stieglitz, Paul Strand, and Edward Weston.

[1] Beaumont & Nancy Newhall, *Masters of Photography* (New York: Castle Books, 1958), p.10.

In 1973, the then curator of photography at the Museum of Modern Art, John Szarkowski, published *Looking at Photographs*. Szarkowski introduced one hundred works from the museum collection, each accompanied by a narrative about the photograph and the photographer. His non-hierarchical approach introduced to the public the work of many lesser known photographers such as John Thomson, Roy DeCarava, and Paul Outerbridge.

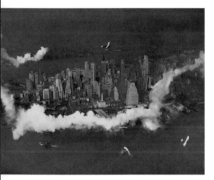

Margaret Bourke-White (attributed)

Smoke Screening

Manhattan, New York

circa 1930

silver print

27.3 x 34 cm (10¾ x 13⅜")

Originally exhibited in Photography Until Now, *1989 at the Museum of Modern Art* .

Szarkowski went a step further in his landmark 1989 exhibition *Photography Until Now* at the Museum of Modern Art. This seminal exhibition occurred during the celebration of the 150th anniversary of photography. In his brief introduction, Szarkowski explained the reasons behind his uncommon approach to his subject: "...I have attempted rather to sketch out a history of photographic pictures, organized according to patterns of technological change...

"It is my hope that this approach will allow the art of photography to be seen not as a special case, peripheral to the larger story of the medium's broad concerns and instrumental functions, but rather and simply, as that work that embodies the clearest, most eloquent expression of photography's historic and continuing search for a renewed and vital identity."[2]

Since the interest in showing photography began to evolve in the 1970s, three basic types of exhibitions with accompanying catalogues have occupied museum walls: The exhibition of the work of a single artist; the photo collection of masters gathered by a museum or a single collector; and, finally, the thematic collection as shaped by the collector or curator.

[2] John Szarkowski, *Photography Until Now* (New York: The Museum of Modern Art, 1989), p.9.

Retrospectives favor the work of a single photographer recognized in the vernacular as a "photographic artist." They are usually accompanied by a monograph on the artist and his work.

Internationally recognized photographers have had one or more exhibitions mounted by leading museums: Alfred Stieglitz, Edward Steichen, Walker Evans, and Edward Weston to name a few. Yet, in spite of their esteemed status, most of these photographers struggled with issues of art and commerce for much of their lives.

Stieglitz was the quintessential art dealer. Steichen photographed for magazines and did commercial jobs. Karl Struss ran a studio, then came west to become one of the great cinematographers of his day. Ansel Adams marketed his photographs and sold them from his Yosemite gallery. In the 1930s and '40s Adams accepted commercial assignments as well. Other photographers such as Ben Shahn, Dorothea Lange, and Walker Evans participated in FSA or Farm Security Administration projects. Evans later photographed for *Fortune Magazine.* Edward Weston lived hand to mouth, often doing commissioned portraits to survive. André Kertész photographed for magazines. Clarence White taught photography at Columbia and later at his Clarence White School. In the 19th-century a number of our greatest photographic artists worked for the government on various surveys. O'Sullivan, Jack Hillers, Alexander Gardner, and William Henry Jackson documented the West. Carleton Watkins sold views for tourists from his San Francisco gallery until he went bankrupt. Eadweard Muybridge worked for the commercial firm of Houseworth and Co.

One job of the critic, curator, and art historian has been to transform these journeymen photographers into artists who would conform to the paradigm presented by the Newhalls in *The History of Photography.* The exhibition *André Kertész, of Paris and New York* shown at the Art Institute in Chicago and the Metropolitan Museum of Art in New York illustrates such a rapprochement. In the preface to the catalogue *André Kertész, of Paris and New York,* curators Sandra S. Phillips, David Travis, and Weston Naef, wrote the following to explain Kertész's vision transforming from that of a successful photojournalist to that of a photographic artist: "His credit may have appeared under fewer photographs than it had five years earlier, but he was a different photographer with larger goals. His personal work, now sparser but richer and moodier than the sparkling abundance of his first years in Paris, subtly began to communicate more complicated moods, and the melancholy solitude of an artist distanced, but not removed, from former enthusiasms became apparent to those who were able to read beyond the nominal subjects of his photographs."[3]

[3] Sandra S. Phillips, David Travis, Weston J. Naef, "Preface" in *André Kertész of Paris and New York* (The Art Institute of Chicago, The Metropolitan Museum of Art, Thames and Hudson, 1985), p.11.

The true artist in any field evolves over a lifetime of work rather than by a brief flash of brilliance. That view, however, does not negate the fact that a strong image, perhaps the equal to an icon, can be made by accident. In recent years, books have begun to illustrate a number of these previously unseen photographs touting them as the latest discoveries, and an interest has broadened to collecting what is loosely termed vernacular photography.

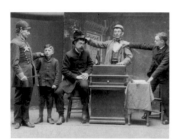

Unidentified

Sam Ross in Dramatics

Portland, Maine

circa 1890

albumen print

15.2 x 21 cm (6 x 8¼")

7 Mia Fineman, "Essay," in *Other Pictures: anonymous photographs from the thomas walther collection* (Santa Fe: Twin Palms Publishers, 2000), [p.1 of essay].

8 Ibid.

Thomas Walther, the New York collector, displayed his vernacular collection on the walls of the Metropolitan Museum of Art in the summer of 2000. By mounting this exhibition, one of the great American institutions made the point that vernacular photographs had at last carved out a place for themselves in the pantheon of the history of photography. Formerly, such pictures had constituted a neglected aspect of that history. Now, photographic oddities, or exceptions, represented a valid counterpart to the historically sanctioned selection of masterpieces.

In the essay that accompanies the book of Walther's selection, *Other Pictures,* Mia Fineman writes: "In 1909 Alfred Stieglitz, the paterfamilias of American art photography, published a list of Twelve Random Don'ts in the magazine *Photographic Topics,* warning amateur photographers not to take themselves too seriously: 'Don't believe you became an artist the instant you received a gift Kodak on Xmas morning,' he cautioned. Stieglitz was understandably wary of the ease with which casual snap-shooters could roll out of bed one morning and, with a minimum of thought, effort, or agonizing self-reflection, achieve the kind of shimmering greatness he felt was best left to trained professionals."[7] Fineman concludes: "But the art of photography is notoriously promiscuous: it doesn't ask for a lifetime of devotion, only for a few moments of passionate attention and voluptuous release. And Christmas morning, with its stimulating blend of surprise, disappointment, and wrenching family psychodrama, is as good a time as any to become an artist."[8]

The Walther collection, *Other Pictures,* makes photography accessible to the average museum visitor. The message is anyone can be a collector: go to the flea markets, find the postcard shows, seek out the paper fairs - and dig around. You too can build a collection of "other photos," and maybe one day, with a little bit of luck, you will have your collection shown on a the walls of a museum. This is the American dream come true.

Internationally recognized photographers have had one or more exhibitions mounted by leading museums: Alfred Stieglitz, Edward Steichen, Walker Evans, and Edward Weston to name a few. Yet, in spite of their esteemed status, most of these photographers struggled with issues of art and commerce for much of their lives.

Stieglitz was the quintessential art dealer. Steichen photographed for magazines and did commercial jobs. Karl Struss ran a studio, then came west to become one of the great cinematographers of his day. Ansel Adams marketed his photographs and sold them from his Yosemite gallery. In the 1930s and '40s Adams accepted commercial assignments as well. Other photographers such as Ben Shahn, Dorothea Lange, and Walker Evans participated in FSA or Farm Security Administration projects. Evans later photographed for *Fortune Magazine*. Edward Weston lived hand to mouth, often doing commissioned portraits to survive. André Kertész photographed for magazines. Clarence White taught photography at Columbia and later at his Clarence White School. In the 19th-century a number of our greatest photographic artists worked for the government on various surveys. O'Sullivan, Jack Hillers, Alexander Gardner, and William Henry Jackson documented the West. Carleton Watkins sold views for tourists from his San Francisco gallery until he went bankrupt. Eadweard Muybridge worked for the commercial firm of Houseworth and Co.

One job of the critic, curator, and art historian has been to transform these journeymen photographers into artists who would conform to the paradigm presented by the Newhalls in *The History of Photography*. The exhibition *André Kertész, of Paris and New York* shown at the Art Institute in Chicago and the Metropolitan Museum of Art in New York illustrates such a rapprochement. In the preface to the catalogue *André Kertész, of Paris and New York,* curators Sandra S. Phillips, David Travis, and Weston Naef, wrote the following to explain Kertész's vision transforming from that of a successful photojournalist to that of a photographic artist: "His credit may have appeared under fewer photographs than it had five years earlier, but he was a different photographer with larger goals. His personal work, now sparser but richer and moodier than the sparkling abundance of his first years in Paris, subtly began to communicate more complicated moods, and the melancholy solitude of an artist distanced, but not removed, from former enthusiasms became apparent to those who were able to read beyond the nominal subjects of his photographs."[3]

3 Sandra S. Phillips, David Travis, Weston J. Naef, "Preface" in *André Kertész of Paris and New York* (The Art Institute of Chicago, The Metropolitan Museum of Art, Thames and Hudson, 1985), p.11.

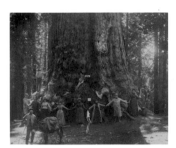

Unidentified

Tourists at General Grant Tree

California

circa 1889

albumen print

17.8 x 23.2 cm (7 x 9⅛")

⁴ John R. Lane,
"Director's Foreword,"
*Crossing the Frontier:
Photographs of the
Developing West, 1849
to the Present,* Sandra
Phillips, Richard
Rodriguez, Aaron
Betsky, Eldridge M.
Moores, (San
Francisco: San
Francisco Museum
of Modern Art-
Cronicle Books), p.9.

⁵ Ann Thomas, "The
Search for Pattern,"
in *Beauty of Another
Order: Photography
in Science,* Ann
Thomas and others
(New Haven and
London: Yale
University Press and
Ottawa: National
Gallery of Canada,
1997), p.76.

The second exhibition format falls into the same history as that of the solo exhibition. The photo "collection" is an assemblage of photographic images that belong to a single museum, several museums, a single collector, or to a combination of museums and collectors. An eclectic selection of the holdings of the Metropolitan Museum of Art, Museum of Modern Art, or the Art Institute of Chicago might contain masterpieces along with lesser known works by major or lesser known photographers. When the exhibition originates from a single collector - for example Sam Wagstaff's in *A Book of Photographs* or Paul Walter's, *A Personal View,* shown at the Museum of Modern Art - the selection can be random with little focus beyond providing images for the pleasure of looking.

Sandra Phillips at the San Francisco Museum of Modern Art was one of the first curators to approach photography thematically with an exhibition titled, *Crossing the Frontier.* Phillips displayed a selection of work from 19th-century to contemporary, from postcards to master works by great western photographers. The director of the museum, John Lane, stated the objective of the exhibition in his foreword: *"...Crossing the Frontier: Photographs of the Developing West, 1849 to the Present* traces the ways photographers have confronted the visual realities of the western landscape over the past 140 years. Unlike other exhibitions of its kind, this one avoids approaches that see the land as a pretext for aestheticization and highlights those that address the land as it has actually been used."⁴

At the National Gallery of Canada, curator Ann Thomas presented an exhibition portraying photography's role in scientific exploration titled, *Beauty of Another Order.* In her essay, *The Search for Pattern,* Thomas probed the obvious contradictions of art and science as they applied to her exhibition: "For scientists, careful and systematic observation of phenomena is the first step in a process of revealing and understanding the patterns through which the workings of nature may be understood. In this context, the photographic images become the permanent record of the act of observation, its explanatory power not automatically guaranteed but predicated to a greater or lesser degree upon the specific circumstances of its making."⁵

Keith Davis, chief curator of the Hallmark Collection, has presented a comprehensive look in his book, *An American Century of Photographs.* Davis defined his mission slightly differently than

others who chose to follow broad themes: "This survey of American photography emphasizes those figures who have used the medium in a deliberately self-expressive manner and, secondarily, those whose works have influenced the way society has thought of itself. These two groups - artists and skilled commercial or journalistic professionals - are not mutually exclusive, though their motivations may differ."[6]

[6] Keith F. Davis, *An American Century of Photographs: From Dry-Plate to Digital* (second edition, revised and enlarged, Kansas City: Hallmark Cards, Inc. with New York: Harry N. Abrams, Inc., 1999,), p.11.

How, then, does one separate the artist from the skilled commercial or journalistic professional, or even the "accidental tourist"? What makes one an artist and the next a documentary photographer? How do O'Sullivan, Watkins, or Southworth and Hawes, all of whom photographed to earn a living, become recognized as artists a hundred years later?

There is a magic to the process, what Szarkowski calls "subjective, unquantifiable knowing," a transformation that has no clear definition or intent, but is engaged in encompassing a broader and broader path. As the curator's knowledge expands, as his or her vision sharpens, as the collector becomes a connoisseur, and as the critic widens his framework, photography develops its own lexicon, following - on the one hand - the conventions of the art world, and on the other a kind of "Dewey Decimal System" of classification reminiscent of the rare book world.

In the field of art history, new discoveries have traditionally lapped upon the shores of the known, adding categories for scholarship and exhibitions to replace those that have dried up. This same principle applies to the field of photography. However, an art of technology and chemistry, photography with its double heritage, that of the art maker and that of those whom Davis calls the "skilled commercial or journalistic professional," has over time fashioned its own cultural model rather than trailed the yardstick of art history.

Photography is only thirty years removed from obscurity, but the interest in every phase of its development continues to grow exponentially. When in the past only a handful of museums like the Museum of Modern Art or the New Orleans Museum of Art had the courage to collect and display photographs, today the photograph has become one of the most desirable additions to any collection. Now, the photograph is shown side by side with paintings and other works on paper, and nobody is questioning its artistic or aesthetic value.

The true artist in any field evolves over a lifetime of work rather than by a brief flash of brilliance. That view, however, does not negate the fact that a strong image, perhaps the equal to an icon, can be made by accident. In recent years, books have begun to illustrate a number of these previously unseen photographs touting them as the latest discoveries, and an interest has broadened to collecting what is loosely termed vernacular photography.

Thomas Walther, the New York collector, displayed his vernacular collection on the walls of the Metropolitan Museum of Art in the summer of 2000. By mounting this exhibition, one of the great American institutions made the point that vernacular photographs had at last carved out a place for themselves in the pantheon of the history of photography. Formerly, such pictures had constituted a neglected aspect of that history. Now, photographic oddities, or exceptions, represented a valid counterpart to the historically sanctioned selection of masterpieces.

In the essay that accompanies the book of Walther's selection, *Other Pictures,* Mia Fineman writes: "In 1909 Alfred Stieglitz, the paterfamilias of American art photography, published a list of Twelve Random Don'ts in the magazine *Photographic Topics,* warning amateur photographers not to take themselves too seriously: 'Don't believe you became an artist the instant you received a gift Kodak on Xmas morning,' he cautioned. Stieglitz was understandably wary of the ease with which casual snap-shooters could roll out of bed one morning and, with a minimum of thought, effort, or agonizing self-reflection, achieve the kind of shimmering greatness he felt was best left to trained professionals."[7] Fineman concludes: "But the art of photography is notoriously promiscuous: it doesn't ask for a lifetime of devotion, only for a few moments of passionate attention and voluptuous release. And Christmas morning, with its stimulating blend of surprise, disappointment, and wrenching family psychodrama, is as good a time as any to become an artist."[8]

The Walther collection, *Other Pictures,* makes photography accessible to the average museum visitor. The message is anyone can be a collector: go to the flea markets, find the postcard shows, seek out the paper fairs - and dig around. You too can build a collection of "other photos," and maybe one day, with a little bit of luck, you will have your collection shown on a the walls of a museum. This is the American dream come true.

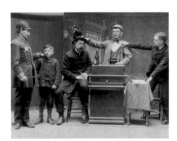

Unidentified

Sam Ross in Dramatics

Portland, Maine

circa 1890

albumen print

15.2 x 21 cm (6 x 8¼")

[7] Mia Fineman, "Essay," in *Other Pictures: anonymous photographs from the thomas walther collection* (Santa Fe: Twin Palms Publishers, 2000), [p.1 of essay].

[8] Ibid.

One of the leading contemporary critics, Geoffrey Batchen, has included a section titled *Vernacular Photographies* in his book of essays, *Each Wild Idea.* Batchen states that the accumulated mass of photographs taken has provided a foundation for the recognized history: "As a parergon, vernacular photography is the absent presence that determines its medium's historical and physical identity; it is that thing that decides what proper photography is not. Truly to understand photography and its history, therefore, one must closely attend to what that history has chosen to repress."[9]

9 Geoffrey Batchen, *Each Wild Idea: Writing, Photography, History* (Cambridge: MIT Press, 2001), p.59.

I was always interested in seeking out the "repressed" and the unknown in the history of photography. However, *The Photograph and the American Dream* did not begin as a clear concept or a specific search. In the 1970s and '80s I had amassed a large personal collection that more or less covered the history of photography with pockets of depth of both known and lesser known photographers. That collection formed the basis of the subject-oriented exhibition, *Parallels and Contrasts,* which opened at the New Orleans Museum of Art in 1988 and traveled to several museums in Europe and the United States. Subsequently, the entire collection was purchased by a Japanese museum in 1990.

Soon after, I embarked upon a new collection. Slowly, I began to gather industry-related images again. A section on science and industry had been included in *Parallels and Contrasts,* but that collection had only been the tip of the iceberg. I felt that the area of industry needed more exploration. After all, the industrial image helped define what America was all about, and the Industrial Revolution had a lasting impact on the world both in war and peace. Photographers documented every phase of the industrial growth from removing raw materials out of the ground to refining them into products and merchandise to marketing them to the public.

In the beginning years, I collected both foreign and domestic subjects: The DeBeers diamond mines and the factories of Europe mingled with photographs showing the Pennsylvania oil discoveries and western mining. Concurrently, I built a collection of advertising images because advertising was the natural link between the manufacturer and the consumer.

My collection of portraits were initially limited to groups of workers, or individual workers, but eventually included business people, celebrities, and others. Then I began to build a collection on

Unidentified

Mohall, North Dakota-ten months old

1904

silver print

5.7 x 30.5 cm (2¼ x 12")

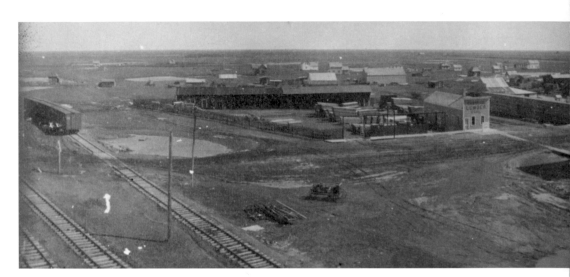

the West, and another on Alaska before and after the gold rush. Russian industrial photographs caught my attention as did photographs of natural disasters, aviation, science, and space. I also worked on a collection of daguerreotypes concentrating on the earliest American images.

I cannot detail my epiphany except to say that one day in New York, while attending the auctions, a colleague offered to sell me a full-plate daguerreotype of the Cleveland family. There they sat, the entire family, staring into the lens of the famous photographer Jeremiah Gurney. Everything about the photograph spoke of a family who had achieved the American dream; the high price they paid to have their likeness reproduced, their clothes, their mannerisms and their expressions. When I bought that image, I also bought an idea that continued to shape and define itself over the next two or three years.

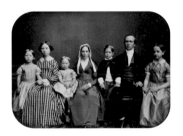

Jeremiah Gurney

Elisha Cleveland Family

circa 1855

full-plate daguerreotype

13.3 x 18.4 cm (5¼ x 7¼")

An American identity! How, I wondered, could that be defined? And what role did photography play in defining it? Certainly, as with the daguerreotype of the Cleveland family, photography at that time defined success. But because of its ability to continue to develop technologically, to grow more and more accessible, photography played a changing role in defining and redefining the American character. In the beginning, the photograph was limited to the affluent, the same small crowd who previously had been the primary recipient of efforts by the miniature painter, silhouette maker, and portrait painter.

Soon, however, for all Americans, no matter how humble, the photograph became an affordable possibility. By the 1860s, photography grew into the most democratic art form of all. Every person, everywhere, could afford to have his or her likeness captured. And a generation or two later, the grandson or granddaughter could buy a camera and record his own life, his family's life, and the world he lived in. Photography seemed to seep through the very pores of the American being.

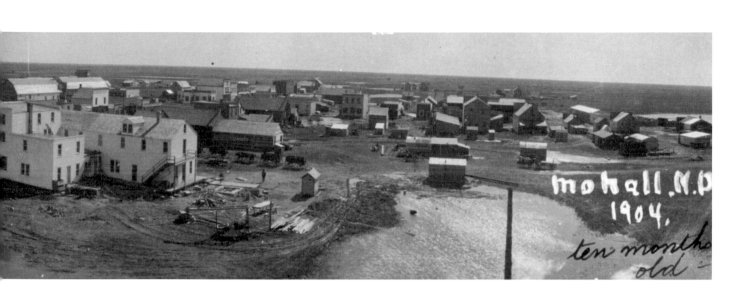

mohall. N.D.
1904.
ten months
old

Within a decade of the Kodak revolution, children recorded the world around them using their Christmas gifts, workers photographed in the workplace, and tourists recorded their travels. The potential to explore the world through the camera was brought into the life of every American.

In an ironic twist, the amateur stampede toward visual literacy freed up the professionals. A snapshot did not negate a studio portrait taken by a competent professional. You might take your own camera to photograph Yosemite, but you would likely return home with the work of a Carleton Watkins, George Fiske, or Ansel Adams to show your neighbors "how it really looked."

Perhaps, you were born too late to see Lincoln or Samuel Morse or Kit Carson in person, but through photographs, and subsequently through photographs reproduced in books, magazines, and newspapers, you learned how to put the name with the face. From the beginning of photography, people could see the world in 3-D. Stereo cards, television for the 19th-century American, offered a world of visual information. A young couple could sit in the parlor and dream of visiting the pyramids just by viewing scenes in three dimensions. All the world was at their fingertips, from the bottom of a coal mine to the first airplane in flight.

Volcanic eruptions of growth triggered rampant geographical and sociological changes across America from 1840 to 1940. The dreams of a few million Americans in 1840 grew five-fold over the next hundred years. A wilderness, once filled with buffalo and wild game, accessible to none but the Native American occupants, had a hundred years later become host to homes for millions seeking a better life. Not quite suburbs, these towns, such as Mohall, North Dakota sprang up across the western countryside. Cities multiplied at an even more frantic pace. New York, Chicago, and Los Angeles grew from being oversized towns into giant centers of trade and commerce. By 1900, Chicago had two million residents, and seventy percent were foreign born. A hundred

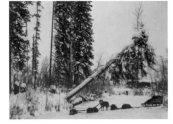

H. J. Goetzman

En Route to the Klondike Gold Fields
by Dogsled

1898, enlarged and printed circa 1920

silver print

45.7 x 60.3 cm (18 x 23¾")

different tongues spoke in their native languages across the land. Swedes, Danes, Germans, Irish, Dutch, Germans from Russia, Jews from Russia, Italians, Greeks, Spaniards, Chinese, and Japanese; all came seeking a better life in a land that offered endless opportunity.

Every fifty years or so, American dreamers produced a get-rich-quick scheme. Around 1850, photographs taken in the gold fields and sent back home, along with newspaper stories of gold strikes, seduced thousands into attempting the arduous trip west. Fifty years later, photographs of the Alaska gold rush sent the grandchildren of the last dreamers, by the thousands, to those remote, frozen shores. Another fifty years passed, and the post World War II building boom took hold, bringing the dream of owning a home to legions of veterans and creating employment to thousands across the country. Now, fifty years later, cyberspace has led to the newest group of dreamers, many of whom have had great success marketing their dreams.

Photography, right from the start, took a firm hold on the American psyche. As the camera became more flexible and the film faster, the intrepid photographer explored every nook and cranny of his material world while also venturing into areas like spirit photography that went beyond the physical world. No subject could safely escape the photographer's eye. The technological progress proved so rapid that within sixty years of the invention of photography, anyone could own a camera that would document his and his family's existence on this earth. The photographic image became our ticket to immortality.

After giving much thought to the task of illustrating in photographs the imprints of the American dream, I decided to lay out the parameters and apportion my collection into six sections: *The American Identities; All Men are Created Equal; Men to Match My Mountains; Manufacturing the Dream; New Frontiers;* and *The City Rises.* Each section would examine an aspect of American life alongside photography's changing role.

The first part documents the dream of finding a new and better life. Waves of immigrants became the backbone of the country while shaping the American identity. Generation after generation came, and their children and descendants helped form the American character. The singular force behind this character was tied to hard work and pursuit of leisure time. Each American carried his destiny in his own hands. Photographers shared in and shaped this destiny. They felt free to explore the land and the heavens, they probed the secret wonders of nature through the X-ray while they sought their own place in this world.

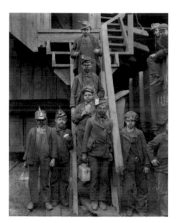

Detroit Photographic Co.

(William Henry Jackson)

Breaker Boys

Scranton, Pennsylvania

circa 1900

hand-colored silver print

23.5 x 18.4 cm (9¼ x 7¼")

Unidentified

Bicycle Parked on

Road to Pike's Peak

Colorado

circa 1900

cyanotype print

18.4 x 23.5 cm (7¼ x 9¼")

Photography, by its mechanical and speedy nature, is fundamentally democratic. Not only can the photograph portray noble presidents but slaves and common laborers as well. Therefore, with its natural ease, the camera also readily captured the heavy price exacted by the quest for equal and democratic rights. It saw violence, the end of slavery, the ugliness of child labor, the struggle for the right of every adult to vote, and labor strikes; all manifestations, however painful and difficult, of gaining the American dream.

In spite of its ability to democratize America, the camera proved to be ideally suited to the glorification of the American icon. The famous could now be seen in all their glory. With their newfound recognition etched in the American mind, the famous were, by the help of photography, made more concrete and longer "living." Romantic figures such as Jesse James and Kit Carson, or inventors such as Thomas Edison and Samuel Morse, a group seldom mentioned in the same breath, were brothers in celebrity hounded by the paparazzi of their day.

Through the advent of photography, the glory of tourist sites grew as fast as the fame of celebrities in the American consciousness. Images of places like Niagara Falls, Yosemite, or Pike's Peak lured dreamers from the comforts of their homes to pursue new adventures - which always lay just around the bend. Iconic moments changed the face of the country as well, historic breakthroughs from the joining of the transcontinental railroad, to the first flight, to the first radio station. While some of these moments arrived with pomp and ceremony, others, like the Wright Brothers' first flight, occurred in isolation and secrecy. Yet, that milestone was also photographed.

Photography was well suited to document the industrial growth resulting from the beginning stage of extracting raw materials out of the earth through to the manufacturing of finished products. The camera captured the worker in the mines and the consumer in the shop. Industry developed an infrastructure for the country, new roads, new railroads, new waterways, advances that gave citizens a better quality of life. The Fairmount Waterworks brought running water to the city of Philadelphia in the 1820s, and Washington D.C. installed its own water system in the late 1850s. Dams and power plants followed the large migration of Americans moving into the Midwest and West. Discoveries of natural gas helped revolutionize home heating. Electricity took hold around the turn of the 20th-century sparking a torrent of newer, easier-to-use products.

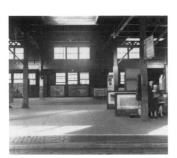

Unidentified
Upham Corners Station
near Boston, Massachusetts
circa 1930
cyanotype print
18.4 x 21.6 cm (7¼ x 8½")

From the development of the factory system in the 1790s to the discovery of oil with its subsequent refinement and uses, from the impact of steam to the use of electricity, all altered the material world and fulfilled dreams of a better life for untold millions. With a flood of new products on the market, advertisement became the link between goods and the consumer. The half-tone printing process, making it easy to print pictures with text, allowed photography to participate in the selling of the dream. By the 20th-century, ads filled the pages of magazines, newspapers, and catalogues.

A network of railroads, canals, ships, and, later, airplanes and automobiles brought distant places and people closer together. A canal system was replaced by the railroads. By 1866 the railroad linked East and West. Air service started in the early 1930s with the help of an adventuresome spirit like Charles Lindbergh. The promise of cheap or free land moved scores of easterners and foreigners west. Expanded transportation and what was called "manifest destiny" seemed to be inexorably linked.

The final section of this exhibition, *The City Rises*, presents the great cities that united the country and gave it power and focus. Cities sprang up all across the continental United States. They became magnets for the poor who started a new migration from the countryside where eking out a living seemed increasingly difficult. The promise of riches abundant in big cities, often depicted in photographs, enticed the rural population to migrate onward. The yearning for a better life moved huge numbers of people across the country, and the camera stalked every detail of their lives.

None of this proved smooth or easy. Often the country extracted a terrible price from the immigrant, the migrant, the poor city dweller, and the homesteader. The camera did not discriminate. It recorded tragedy and comedy alike, the alpha and omega. It probed deep into our personal and communal lives, coughing up the good, the bad, and the ugly.

But nothing kept us from dreaming and doing - not the camera, not the busts. Free as the air we breathe, an American dream never cost anyone a plug nickel. No wonder we had so many dreamers and doers. And with a fair share of grace and prowess - and two strong legs to boot - we beautiful dreamers may still, after making it through our bad days, carry the good days.

Los Angeles, 2001

A EUROPEAN
DREAM

Andreas Blühm

The laptop computer being used to write this text also contains low-resolution scans of the photographs from Stephen White's collection. If I fail to press a key or move the mouse for more than a minute, the screensaver is activated and the images start to appear, changing every six seconds. The pictures are chosen at random with no regard for either chronology or motif. Pure fortuity is obviously a principle no human curator would choose to adopt, but the program does in a way help answer the question I would like to explore in this essay: how do we recognize an American photograph? Is there a commonality between a daguerreotype portrait from 1841 and a view of the Empire State Building construction site in 1930 simply because both were made in the United States? And if so, what might it be based on: the motif, formal qualities, or the viewer's preconditioned visual expectations?

Columbus had hardly returned from his first voyage to the so-called New World when a flood of written and visual information about his discoveries began to arrive in Europe. We like to think that it was modern phenomena like film, television and popular culture that fashioned our - now thoroughly internalized - vision of America, but it seems likely that the engravings, paintings and written testimonies of earlier times probably left an even deeper impression. The connections between Europe and the United States are so multifaceted and complex that it seems safe to say that there can be no one image of America. The amount of available material alone would make such a statement impossible, just think of the variety of sources: a letter of an emigrant relative describing the living conditions "on the other side of the great pond"; the novels of James Fenimore Cooper or Karl May; a report on the American election campaign; the experience of a Wild West Show with William Cody - alias Buffalo Bill - or one of his successors. Every non-American thus already possesses a stock of images that play a determining role even before he or she has begun to try and understand the land Columbus "discovered."

Photography is the medium through which most Europeans have gotten to know America. It has replaced the graphic arts, but has not itself been superseded by either film or television. Stephen White's "American Dreams" collection provides us with a representative overview of American photography during its first century. My initial introduction to a selection of these pictures, spread out on a large table at the collector's home, was truly astonishing. Their compelling "otherness," the sense of both relationship and difference, the confirmation and almost simultaneous repudiation of my European prejudices - all this fascinated not only the art historian in me.

Further Reading:

Klaas van Berkel (ed.), *Amerika in Europese ogen: facetten van de Europese beeldvorming van het moderne Amerika* (The Hague: SDU Uitgeverij, 1990);

Benedetta Cestilli Guidi and Nicholas Mann (eds.), *Photographs at the Frontier: Aby Warburg in America 1895-1896* (London: Merrell Holberton Publishers, 1998);

William L. Chew III (ed.), *Images of America: Through the European Looking-glass* (Brussels: VUB Press, 1997);

Rob Kroes(ed.), *The American West as seen by Europeans and Americans* ([European Contributions to American Studies xiv], Amsterdam: VU Uigeverij, 1989).

But where does this fascination come from? While my first visit to Stephen White was mainly about our getting to know one another, the second was characterized by hard, if pleasurable, work. We had decided to make a choice of 200 pictures for the exhibition - from a collection that contains many hundreds. I imagined myself taking the role of objective guest, whose task it was to keep the collector in check. While a collector loves everything in his collection equally, my job as curator was to keep an eye on quality and on the interests of the museum public. In the end, however, it was Stephen White who had to restrain me, as I became increasingly carried away with the photographs, and less and less willing to give any of them up.

The question is: is their something typically American about the American photograph? Everyone will agree that it is relatively easy to identify photographs from the United States. This is due to a number of factors, most importantly the motifs themselves. Americans and non-Americans recognize the majority of landscapes, buildings and symbols with equal rapidity: Monument Valley, the White House, and the Statue of Liberty are, of course, only to be found in the USA. Nor can either the professional documentary photograph or the vacation snapshot easily avoid the ever-present Star Spangled Banner. And even less prominent features can help reveal the identity of an American photograph: for all their diversity, the cars, clothing, and houses all have a certain style, common characteristics that quickly betray their origins. The closer the camera gets to its object, however, the more difficult it becomes to pinpoint it. The portrait of a stranger or view of a factory can often just as easily have been taken in other parts of the world. Things become even more problematic when it comes to the attitudes and convictions that supposedly characterize the American turn of mind, and which therefore ought to be visible in the American photograph: a pioneering spirit, self-confidence, a desire for liberty, individualism, sometimes even brutality, arrogance and ignorance - or all of them at once. It is the same here as with the photograph itself: the closer the lens gets to its subject, the harder it is to generalize. Distance, both physical and mental, is therefore necessary if one wants to uncover similarities and common attributes.

Photography is, of course, a medium with a claim to objectivity. What we see in a photograph did, in fact, once exist and look the way we see it in the picture. The lens instantly captures the perspective lines that a painter must first carefully reconstruct, using both science and mathematics. Only optical lines exist between the lens and the object. Still, photography - as everyone now knows - is also subjective, dependent not only on the angle chosen by the photographer, his

interests and temperament, but also on a variety of conventions and the style of the period. Finally, there is the question of how the image is reproduced, as well as viewed and consumed. One can thus claim that even in a technical and formal sense, objectivity is greater when a certain aloofness is preserved. Foreign inspectors monitor elections because they have no ties to the country in question, and therefore no stake in the outcome. While ignorance and indifference will never produce a satisfactory result in painting, in photography they can be a great advantage, the prerequisites for a successful image. A newspaper photographer who is swept away by events no longer has the remove necessary to trigger a reaction in the viewer.

Looking at photographs from America gives rise to many questions. Do American photographers have a different kind of distance to their country than, for example, European? Aside from the continent's original inhabitants, every American is an immigrant or the descendant of immigrants. The question arises when a newcomer loses his sense of separation and begin to identify with his adopted land. Which internalized images does the photographer already bring with him and for how long does he make comparisons with his country of origin or see with the eyes of the Old World? Perhaps he seeks to create a new pictorial language, in order to free himself from just these ways of seeing.

The first era of travel to America, and thus of European reception of the new continent, can be broken down into three major periods: from 1492 (Columbus's landing) to 1642 (the arrival of the *Mayflower*), from 1642 to 1783 (the end of the War of Independence), and from 1783 to 1861 (the outbreak of the Civil War). Columbus's voyages had had an immediate and profound impact on European intellectual life, and his *Epistola de insulis nuper inventis* was published in pictured editions. Many of the early woodcuts and engravings concentrated on encounters between Europeans and the continent's native inhabitants, but it was above all the descriptions - illustrated or not - of the landscape, plants, and animals that gave those who stayed at home an impression of the immeasurable breadth and variety of the New World. Another source of information were the pamphlets recruiting new colonizers, which included accounts of the individual states and regions, and commentary on their economic viability. It is interesting to note that these early reports were extraordinarily differentiated; they were not what one would call unadulterated hymns

[1] Reimer Eck et al. (eds.) *Nordamerika aus Sicht europäischer Reisender: Bücher, Ansichten und Texte aus vier Jahrhunderten,* exh. cat. (Hanover, Amerika-Haus, 1991), passim.

[2] Kathleen Pyne, "Amerikas Verständnis der eigenen nationalen Kunst," in *Bilder aus der Neuen Welt: Amerikanische Malerei des 18. und 19. Jahrhunderts,* exh. cat., Thomas W. Gaehtgens (ed.) (Berlin: Staatliche Museen Preußischer Kulturbesitz, Nationalgalerie, Orangerie des Schlosses Charlottenburg and Zürich: Kunsthaus Zürich, 1988-89), pp. 121-25, here p. 121, and passim.

[3] Udo Sautter, *Geschichte der Vereinigten Staaten von Amerika* (1975 6th rev. ed., Stuttgart: Kröner Verlag, 1998), pp. 172-74.

[4] Thomas W. Gaehtgens, "Die amerikanische Malerei des 18. und 19. Jahrhunderts aus der Sicht Europas," in *Bilder aus der Neuen Welt: Amerikanische Malerei des 18. und 19. Jahrhunders,* exh. cat., Thomas W. Gaehtgens (ed.) (Berlin: Staatliche Museen Preußischer Kulturbesitz, Nationalgalerie, Orangerie des Schlosses Charlottenburg and Zürich: Kunsthaus Zürich, 1988-89), n. 2, pp. 13-30, here p. 17.

[5] Lois Marie Fink, *American Art at the Nineteenth-Century Paris Salons* (Cambridge: Cambridge University Press, 1990), p. 9.

of praise for a land of infinite opportunity - although this had little affect on the tides of immigrants. This propaganda material usually contained few illustrations, and until the late 19th-century offered little more than sober views of provincial towns and small harbors.[1]

The invention of photography occurred in the latter decades of the third phase. But America had already entered Europe's consciousness long before, and by the dawn of the age of photography, the continent was no longer a primeval wilderness. Both coasts had been settled. and there was not much left to discover in between. By 1841, the 26 United States had a modern and progressive constitution, and had already elected ten presidents. In 1830, 70% of the books read in the u.s. were still published in England, but 30% were already being produced domestically. In 1837, Ralph Waldo Emerson called upon his compatriots to embark on a process of intellectual self-discovery, and James Fenimore Cooper's novels *The Last of the Mohicans* (1826) and *The Deerslayer* (1841) began to tell the story of the decline and downfall of Native American culture. The sculptor Horatio Greenough warned art students going abroad of the dangers of "aristocratization."[2] Even the customs and society of New England's early colonists became an object of nostalgic retrospection in the work of Nathaniel Hawthorne. Around the middle of the 19th-century, George Bancroft began working on his ten-volume *History of America* - a sure sign that the country had outgrown its pioneer roots.[3]

The dependence on, or conscious differentiation from, an ever-renewing European influence - the result of continuing immigration - was also a dilemma for 19th-century American artists. Many felt it was their patriotic duty to create an "image" of their native land, its landscapes and inhabitants: "The need to become independent of Europe not only politically, but also artistically, was already a topic of discussion in the early 19th-century."[4] Before the invention of photography and during its first decades, paintings from the United States were occasionally shown in Europe; their impact, however, was minimal - due in part to their small numbers. Lois Fink has analyzed the presence of American painters at the Paris Salon: before 1850, only 60 American pictures were displayed at this important forum for contemporary art. The works of Benjamin West, Washington Allston and John Vanderlyn could hardly be distinguished from those of their European colleagues - a fact these artists would certainly have been proud of.[5]

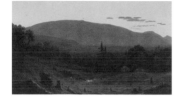

Sanford Gifford

Twilight on Hunter Mountain

1866

oil on canvas

Daniel J. Terra Collection, Musée

Americain, Giverny, France

6 Ibid., p. 88.

7 Thomas W. Gaehtgens (ed.), *Bilder aus der Neuen Welt: Amerikanische Malerei des 18. und 19. Jahrhunderts,* exh. cat. (Berlin: Staatliche Museen Preußischer Kulturbesitz, Nationalgalerie, Orangerie des Schlosses Charlottenburg and Zürich: Kunsthaus Zürich, 1988-89), n. 2 pp. 18-23.

8 Barbara Novak, *Nature and Culture: American Landscape and Painting, 1825-1875* (New York: Oxford University Press, 1980), fig. 79, p. 158.

Later, the Americans hoped to impress the sophisticated French audience not only with their continent's majestic scenery, but also with the abilities of its new school of painting. The critical reaction to the masterpieces by Albert Bierstadt, Frederic E. Church, Winslow Homer, Jasper F. Cropsey, Asher B. Durand, Sanford Robinson Gifford, George Inness, John F. Kensett, and Thomas Moran shown at the Exposition Universelle of 1867 dealt a terrible blow to the nation's self-confidence. The French critics described the landscapes as evidencing nothing but "infantile arrogance" and "childish ignorance."[6] Even the Americans themselves had trouble appreciating the particular qualities of their own art, and it was only in the 20th-century that representatives from the Old World were able to convince them that there was no need to feel inferior. It was the Europeans who helped the Americans rediscover the special nature of American painting, perhaps because they paid less attention to the names of the artists - which often meant nothing to them - than to the works themselves. Armed with this unbiased vision, they were able to distinguish some of the typical *formal* characteristics of American paintings. Thomas Gaehtgens has identified these as the horizontal format; a lack of *repoussoir;* a "matter-of-factness" in the representation of genre scenes, but also a certain monumentality. The paintings speak of a reverence for the forces of nature, decency, and sincerity and pride in the country' s newly developed - and recently recognized - national virtues.[7]

In the early period, photography could hardly compete with painting as far as motifs were concerned: trappers in canoes, Indians on the hunt, and mountain landscapes at sunset could only be captured on canvas. The painter's fantasy was still better equipped to propagate the myth of the West than the photographer's camera. Initially, then, any direct comparison has to be ruled out. As soon as painters and photographers were able to treat the same subjects, however, some interesting perspectives are opened up, ones which make the disparity between the two mediums immediately obvious. Sanford Gifford's *Twilight on Hunter Mountain* of 1866 (oil on canvas, 30 x 54 in., Daniel J. Terra Collection, Musée Americain, Giverny, France) is one of those works in which the putative emptiness and availability of the American landscape finds its archetypal expression.[8] Such paintings led the way for photography. Photographers were forced to measure their products against such compositions, either through imitation - i.e. by adopting painterly conventions - or through conscious rejection - i.e. by seeking to convey a sense of the immediate and unaffected. This appears to be the aim, for example, of the photograph of a group of homesteaders clearing the land by an unidentified photographer around 1880. In Gifford's painting,

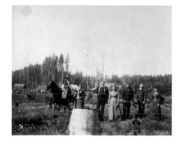

Unidentified

Homesteaders Clearing the Land

circa 1880

albumen print

19.7 x 24.1 cm (7¾ x 9½")

the wide format and balanced composition create the impression of sublimity; the viewer looks down from a lofty standpoint at the landscape below, where tiny tree stumps bear witness to the "beneficent" activities of the pioneers. In the photograph, on the other hand, we are suddenly returned to earth. The tree stump reveals itself to be the remains of a considerable obstacle, cleared away only with the greatest of difficulty in order to create a space for the settlement. The settlers themselves are expressionless and clearly surprised that anyone could possibly be interested in recording their efforts for the sake of future generations. There is no sense of pride in their achievement to be read on their faces.

William Ranney's *Scouting Party* of 1851 (oil on canvas, 22 x 36 in., Thyssen-Bornemisza Collection) is another kind of icon, designed to instill a sense of fear and respect for the wilderness in the visitor to the urban picture gallery.[9] Here, too, the detailed execution and (purported) topographical accuracy help establish the work's claim to verisimilitude. The viewer's expectations are thus fulfilled: of all the truly heroic moments in the life of the lonely pioneer, the only one worthy of depiction is that which points to future conquests, and not to his ongoing struggle for survival. For all its superficial realism, then, the painting is actually the visualization of an abstraction. Photography could not compete with such imagery. It had to come up with something of its own to set against this mythical vision of America.

This did not, of course, mean that early photography in America had no need or desire to discover the new. Like the medium itself, which was invented in Europe, every wave of immigrants to the United States brought with it fresh batches of European photographers. What should be obvious by now, though, is that these photographers - and their customers - each already carried with them a weighty cache of (imagined) images.[10] The photographers' mobility, however, allowed them to focus on those aspects of American life that painters had ignored as "un-picturesque": for example, the colonizers and their outposts, rather than the dramatic features of the landscape and the Indians and their customs. Photography arrived in America just when the Americans had begun to reflect on their own values and culture. A decisive factor was certainly that the photographers' first clients, and thus the earliest recipients of American photography, were private citizens, who wanted nothing more than a record of their families and possessions for themselves. They certainly showed the pictures to their friends and relatives, but they were not meant for a broader, anonymous audience.[11]

[9] William H. Truettner (ed.), *The West as America: Reinterpreting Images of the Frontier, 1820-1920* (Washington: National Museum of American Art and Denver: The Denver Art Museum and Saint Louis: The Saint Louis Art Museum, 1991-92), fig. 94, p. 112.

[10] Even then, it seems - although to a some what lesser extent - David E. Nye's words rang true: "Some sites are photographed so often, such as the New York skyline seen from the Staten Island Ferry, that what is recognized is not the particular image but rather the visual subject. Putting this another way, for a selected group of visual subjects people have internalized the captions"; see: "Transnational photographic communication," in *American Photographs in Europe,* David E. Nye and Mick Gidley (eds.) ([European Contributions to American Studies XXIX], Amsterdam: VU Uitgeverij, 1989), pp. 18-40, here p. 19.

[11] The exception proves the rule: "At the first World's Fair, the Crystal Palace Exhibition of 1851, American daguerreotypes were praised, and the highest medals went to Mathew Brady and two other American photographers"; ibid, p. 5.

The Europeans who stayed on in the Old World would long remain dependent on images of America that displayed a much higher degree of artistic manipulation and interpretation than original photographs. They continued to draw on the copperplate engravings and woodcuts reproduced in illustrated magazines. These were sometimes based on photographs, but were also subject to the conventions of genre painting. Railroads, stagecoaches, paddle-steamers on the Mississippi, traffic on the streets of large cities, tourist attractions like Niagara Falls, and the occasional plantation were the most popular motifs. In these media, the long-standing clichés were repeated almost to the point of exhaustion. Native Americans, too, were still often shown, now no longer in their encounters with the settlers, but rather in their own environment, engaged in their specific customs, such as dancing and hunting. The fear of these "savages" having diminished somewhat, illustrators could now concentrate on details of costume, headdress and body painting. The images made for Americans, however, showed other things and/or in a different way.

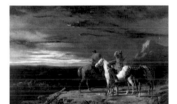

William Ranney

The Scouting Party

1851

oil on canvas

Thyssen-Bornemisza Collection

Lugano-Castagnola, Switzerland

The construction of the railroad was frequently photographed, as was work in general. Villages were built in the space of only a few days and destroyed even more quickly by tornadoes. Photographers captured both. Machines, factories and other technical achievements were recorded for the purposes of advertising or propaganda. Photographs sold America's products, mainly to Americans themselves. Europeans only encountered such images at a much later date. Events and personalities of the day were depicted, in order to encourage Americans to participate in the nation's social life. A photograph of Lincoln showed Americans either a role model or the political enemy. Europeans, on the other hand, regarded him simply as another statesman from a foreign land.

What consequences might this have had for the formal side of photography? Are there similarities between American photographs and American paintings? Is there a difference to European photography? Let us now look again at the characteristics noted by Thomas Gaehtgens with regard to American paintings: the horizontal format, the lack of *repoussoir*, "matter-of-factness" in the representation of genre, but also a certain monumentality. It is astonishing, but these generalizations can actually be applied to the photographic medium itself. "Matter-of-factness" is, actually, one of its primary attributes. This is equally true of European photography, however: here, too, there were few Romantic spirits among photographers.

Unidentified

Aby Warburg with a Hopi dancer

Oraibi, Arizona

May 1896

The Warburg Institute

University of London

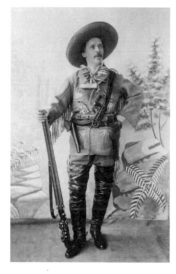

Unidentified

Karl May dressed as Old Shatterhand

1896

Karl May Gesellschaft

Two Europeans in America? The cultural historian and anthropologist Aby Warburg went to Arizona to study the customs of the Hopi, but had only little influence on the knowledge of Europeans of the native cultures. Karl May had a lasting effect on the European perception of the Wild West. Here he dresses as his hero Old Shatterhand, the friend of the Apache chief Winnetou.

The laptop once again parades a selection of photographs from Stephen White's collection. Panoramic landscapes, smoking factory chimneys, the development of Long Island, the window of a shoe store, and people at work all follow, one after the other, with no recognizable connection. The American dream - and its reverse - is revealed in a different way in each and every one. Looking at them, the European is repeatedly confronted with images of landscapes, people, or combinations of the two, that are at variance with those of his own world. What predominates, however, is a sense of recognition. This strange landscape is known to us from descriptions, from films - it now belongs to us, too. The same is true of the majority of buildings and monuments. The Caucasians among those depicted, and they are, of course, the majority - between 1840 and 1940, Afro-Americans and Indians played only the role of bystanders in their own country - are near and distant relatives. Furthermore, they were mostly photographed by American photographers of European descent, who regarded them from their own (European) point of view. One might even argue that in the first decades, photography showed Europeans America from a European perspective, while later photographs - since about the 1920s - spread so quickly that they actually became part of the European visual heritage: "Look here, that's what our ancestors achieved."

America is thus only "Other" in a limited sense; the photographs show Europeans themselves in slightly different circumstances, in a larger territory, in a new and more mixed configuration. For the European, these images from America show not the American, but the *European* dream.

Amsterdam, 2001

AMERICAN IDENTITIES

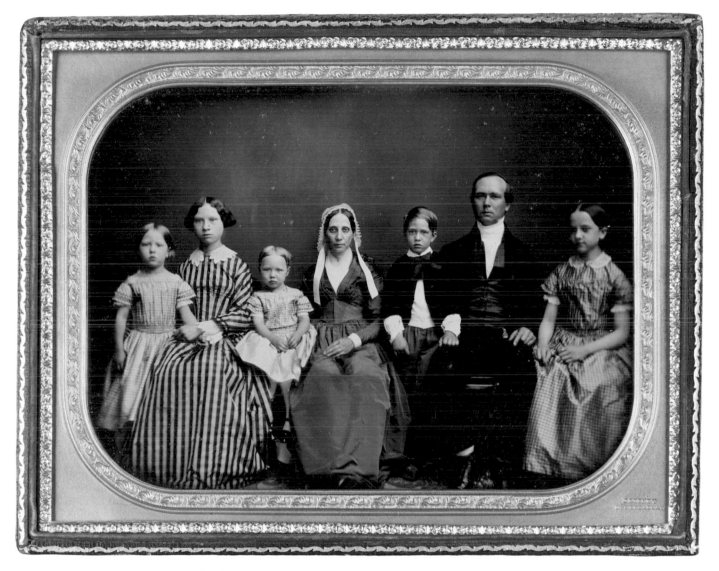

7 Jeremiah Gurney

Elisha Cleveland Family

circa 1855

full-plate daguerreotype

13.3 x 18.4 cm (5¼ x 7¼")

Frank, brave, cordial, hospitable, and distrustful; such were the American traits recited by Charles Dickens in 1842. However much we prefer to believe that we are more than a rough outline, these qualities, simple and direct, may well offer a fair thumb-sketch of us.

We live in a world filled with liberties and obstacles. Each of us goes through life like a juggler keeping an eye on the ball. We come from immigrant stock, from nowhere and everywhere. What we see in the photographs is ourselves; our dreams and our disappointments. Here is the worker, the small businessman, the homeowner, the politician - the renowned, the infamous, and the obscure.

The earliest daguerreotype reveals a circa 1840 picture of an elegant woman using her hand to support her head. She has secured her head for an exposure that took several minutes. In return for her hard work, she has gained immortality (pl.8). The studio portrait of an unknown man by Huddleston was made in the summer of 1841 (pl.9). The former thermometer maker opened a portrait studio for a mere two months. Only two examples of his work are known.

The Blair family holds the frozen pose demanded by all early sitters (pl.10). A circa 1843 daguerreotype shows a woman standing in the window. The photographer had placed himself outside the house. His outdoor position, a sign of Yankee ingenuity in action, puts enough light on his subject to make an exposure (pl.11). Young Sert Wilson sits in stark contrast to her tired looking mother in a circa 1844 image (pl.12). Behind the daguerreotype is a letter addressed to Sert from her sister.

The next three pictures, along with the Gurney full-plate daguerreotype of the successful Cleveland family (pl.7), demonstrate the dramatic changes taking place during the first fifteen years of photography. The informality of the woman posed on her man's lap is unusual for the 1850s (pl.13). Louisa Whiteside, a proud dieter, is pointing to a daguerreotype of her former overweight self (pl.14). The daguerreotype of three friends reveals the work of an unidentified, but masterful photographer (pl.15).

When paper replaced the daguerreotype, it meant that the size of the image could be increased and its clarity improved. The early Brady Imperial print exemplifies the advancement in 1850s

photographic portraiture (pl.16). The portraits of the Boyard brothers serve as early examples of exquisite pastel-colored prints. One was photographed in 1855 at the American Daguerrian Gallery in Paris (pl.17a). The other was probably taken later at the Frederick's Studio in New York (pl.17b).

Faster exposures allowed the camera to capture the informal pose of a wrongly accused conspirator in the Lincoln assassination (pl.19). It caught the grim expression on an immigrant face etched from the hard life on the plains (pl.18). The camera saw the pleased look of two young men, brimming with confidence, hats in hand (pl.32). A California amateur, John Stick, presented "Marie" as the idealized women in 1920 (pl.21). The pose of a California matron in front of her mansion circa 1935 signifies the emergence of the independent woman in American society (pl.23).

The captain and first mate of a riverboat (pl.26) and the small shop owners depict Americans at work (pl.27). A group of loafers introduces us to Americans at play (pl.28). Photographs showing how we spent our newfound leisure time include the 1889 picture of a pigtailed woman diving off a boat (pl.29), men bathing as they prepare for a night on the town (pl.31), and the comic flying collage that sent off a couple on vacation (pl.30). Finally, the photographer turns the camera on outer space (pl.37 & 38), inner space (pl.35), and even on himself as seen in the self-portrait by Eadward Muybridge in motion (pl.36).

Our American Identity! We, the people indivisible, seen through the eye of the camera; then revisited and re-examined through the eye of hindsight.

8 Unidentified

Woman with Hand to Cheek

circa 1840

daguerreotype

7 x 5.7 cm (2¾ x 2¼")

9 John S. F. Huddleston

Man in Studio

Boston, Massachusetts

1841

daguerreotype

7 x 5.7 cm (2¾ x 2¼")

10 above, Unidentified

Blair Family

New Jersey or Pennsylvania

circa 1842

daguerreotype

8.3 x 6.4 cm (3 ¼ x 2 ½")

11 top right, Unidentified

Woman Facing out Open Window

circa 1843

daguerreotype

7.3 x 6 cm (2 ⅞ x 2 ⅜")

Early itinerant photographers
often used exterior light to help
with the exposure.

12 bottom right, Unidentified

Sert Wilson and her Mother,

Washington D.C.

circa 1844

daguerreotype

6.4 x 5.7 cm (2 ½ x 2 ¼")

13 Unidentified

Woman Sitting on Man's Lap

New York?

circa 1855

daguerreotype

5.7 x 5.7 cm (2 ¼ x 2 ¼")

14 Unidentified

Louisa Whiteside Pointing at a
Daguerreotype Image of her Heavier
Former Self

circa 1848

daguerreotype

8.9 x 6.4 cm (3 ½ x 2 ½")

15 Unidentified

Friendship, Three Girls

circa 1853

daguerreotype

8.9 x 6.4 cm (3 ½ x 2 ½")

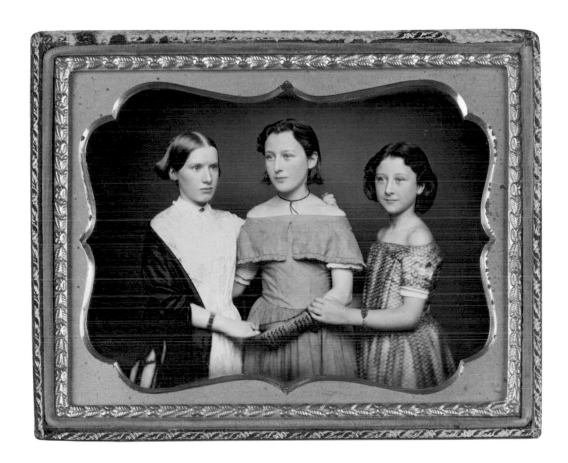

16 Mathew Brady

Unidentified Man

New York

circa 1856

Imperial salted paper print

47 x 39.4 cm (18 ½ x 15 ½")

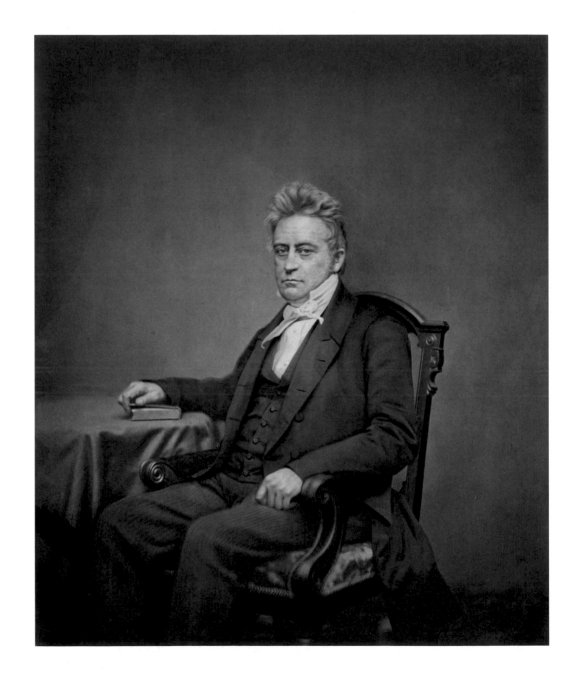

17a Galerie Americaine

(Frederick's, Penbert & Leblanc)

Thomas Boyard (Boquard)

1855

pastel over salted paper print

54.6 x 43.2 cm (21 ½ x 17")

17b Unidentified

(attributed to Frederick's Gallery)

Theodore Boyard

circa 1858

pastel over salted paper print

54.6 x 43.2 cm (21 ½ x 17")

According to a note accompanying
the pictures, the Boyard brothers
owned a talc mine near the
Canadian border.

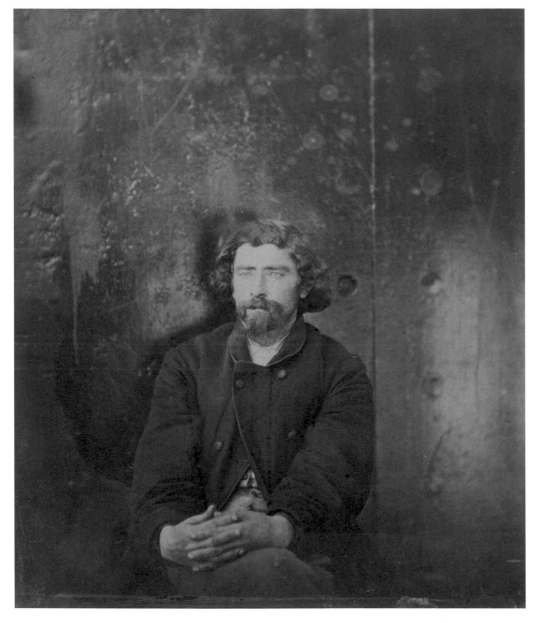

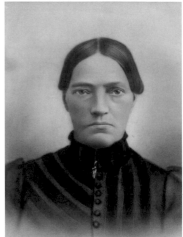

18 above, Unidentified
Woman Immigrant
North Dakota?
circa 1900
charcoaled silver print
40.6 x 30.5 cm (16 x 12")

19 left, Alexander Gardner
Hartman Richter?
1865
albumen print
22.2 x 17.8 cm (8 ¾ x 7")

Richter was the cousin of George
Atzerodt, a conspirator in the
assassination of Abraham Lincoln.
They were both arrested at
Richter's house in Maryland.
Richter was released a short time
later. This image was previously
misidentified as Dr. Mudd, another
suspect in the conspiracy.

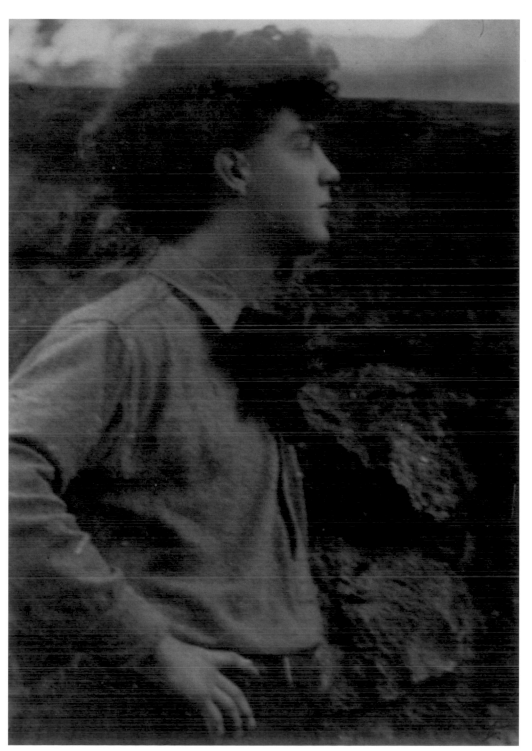

20 Paul Fournier

Self-portrait

circa 1905

platinum print

16.5 x 11.4 cm (6 ½ x 4 ½")

Fournier was a member of the

photo-pictorialists of Buffalo, New York.

21 John Stick

Marie

1920

bromide print

34.3 x 24.8 cm (13 ½ x 9 ¾")

*Stick exhibited "Marie" in the
1921 London Salon of Photography,
the 1921 Pittsburgh Salon, and
the Southwest Museum Exhibition
(Los Angeles) in 1925.*

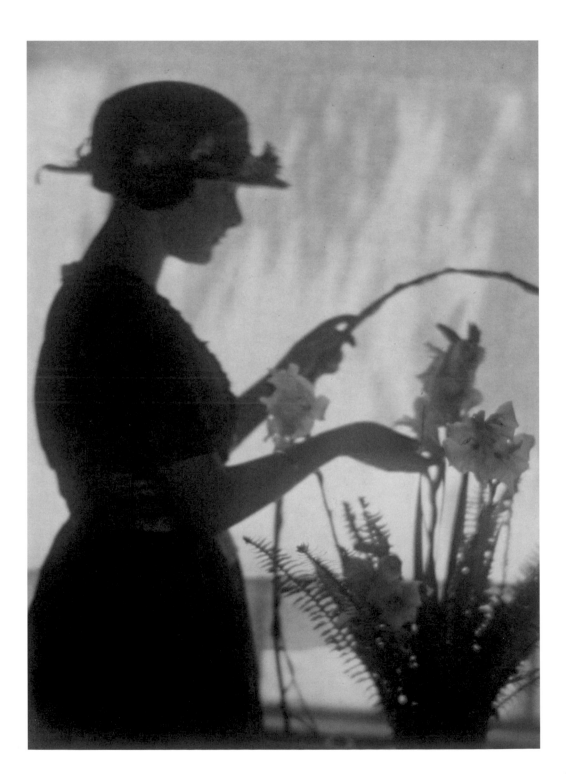

22 Unidentified

Mrs. Brown

1907

hand-colored silver print

54.6 x 39.4 cm (21 ½ x 15 ½")

*On the wooden backing of the
frame is written: David Brown,
1 frame, 1 (January), 07.*

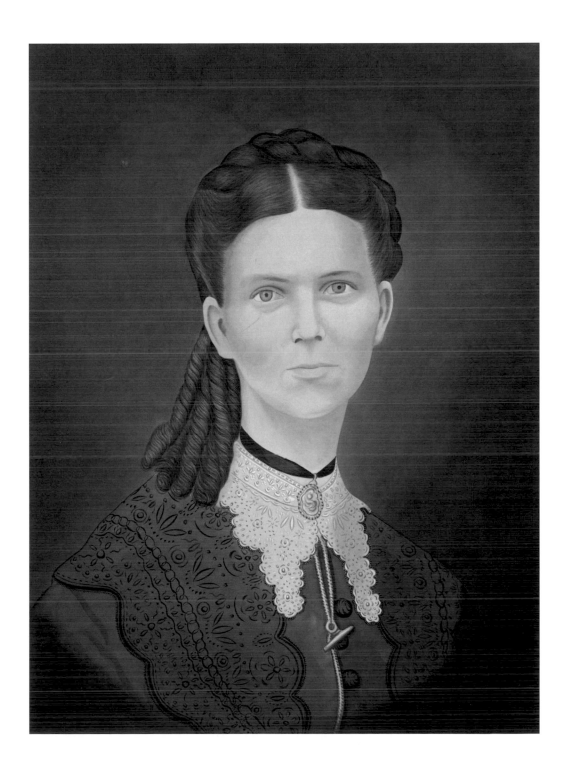

23 James Doolittle

Woman Homeowner

Pasadena?, California

circa 1935

tricolor carbro print

44.5 x 32.4 cm (17 ½ x 12 ¾")

24 Unidentified

Ed Behney's Stock Farm

Fowler, Kansas

circa 1900

toned silver print

15.2 x 20.3 cm (6 x 8")

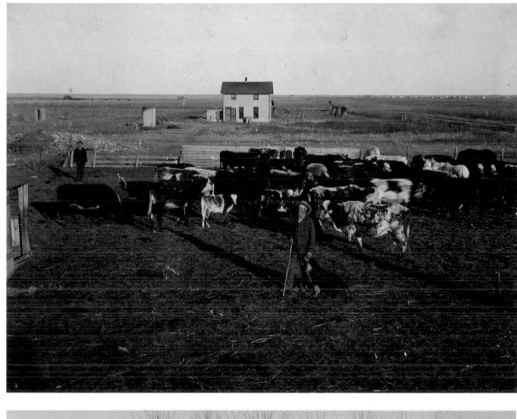

25 H. B. Eggert

An Upper-Class Family Home

Bethlehem, Pennsylvania

circa 1875

albumen print

24.1 x 29.9 cm (9 ½ x 11 ¾")

*Left to right are the two
grandmothers, the nurse, baby,
mother, four children. The
two servants are visible in the
window behind the children.
The family dog appears to have two
heads because of movement
during the exposure.*

26 Elbridge Moore

Captain and Mate of the Kassald,

Columbia River, Oregon

1886

albumen print

19.1 x 14.9 cm (7 ½ x 5 ⅞")

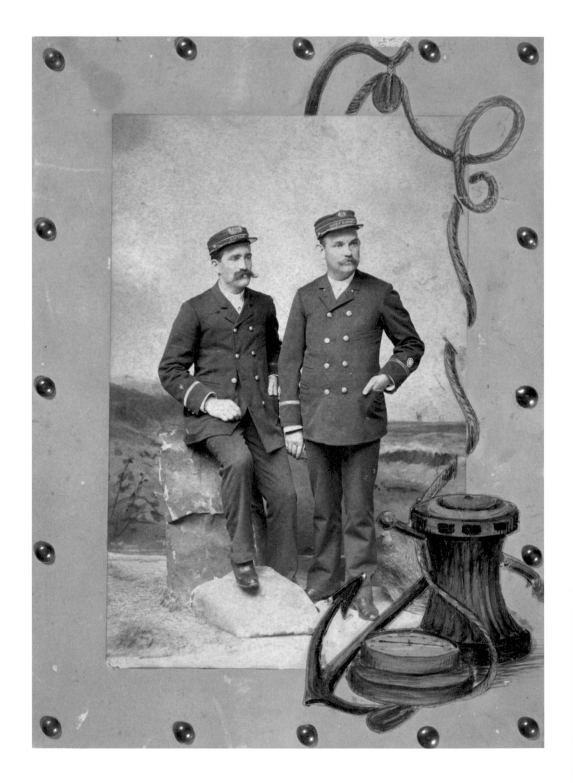

27 Unidentified

Van Ness Cash Grocery

San Francisco, California

circa 1900

aristotype print

11.4 x 16.8 cm (4 ½ x 6 ⅝")

28 Unidentified

Patent Medicine Drug Store

Western United States

circa 1895

silver print

11.8 x 16.5 cm (4 ⅝ x 6 ½")

29 John S. Johnston

Woman Diving

Coney Island, New York

1889

albumen print

16.5 x 19.7 cm (6 ½ x 7 ¾")

This photograph, taken from
a rowboat, would have required a
hand-held camera.

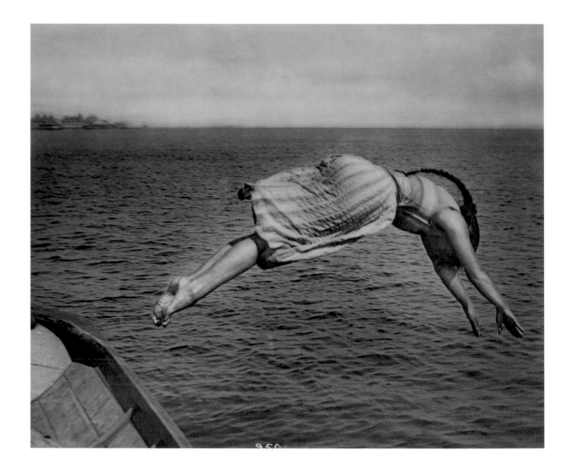

30 Unidentified

Aviation Collage

Ohio?

circa 1915

watercolor and photograph

25.4 x 35.6 cm (10 x 14")

31 Unidentified

Saturday Night Bath

California?

circa 1905

silver print

9.8 x 13.7 cm (3 ⅞ x 5 ⅜")

32 Unidentified

Two Young Men with Bowler Hats

circa 1900

cyanotype print

24.5 x 19.1 cm (9 ⅝ x 7 ½")

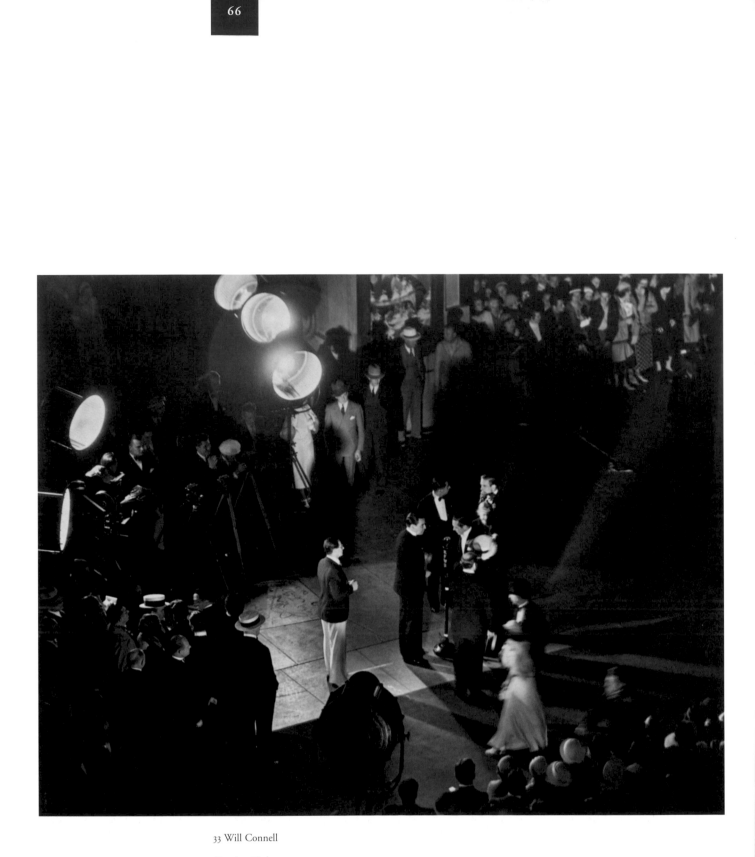

33 Will Connell

Opening Night

Hollywood, California

circa 1933

silver print

19.1 x 24.1 cm (7 ½ x 9 ½")

34 William P. Mayfield

Columbia Theatre

Dayton, Ohio

circa 1925

silver print

20.6 x 25.4 cm (8 ⅛ x 10")

Mayfield made publicity photos for the Columbia Theatre. He had the theatre open the box office late in order to photograph the waiting crowd.

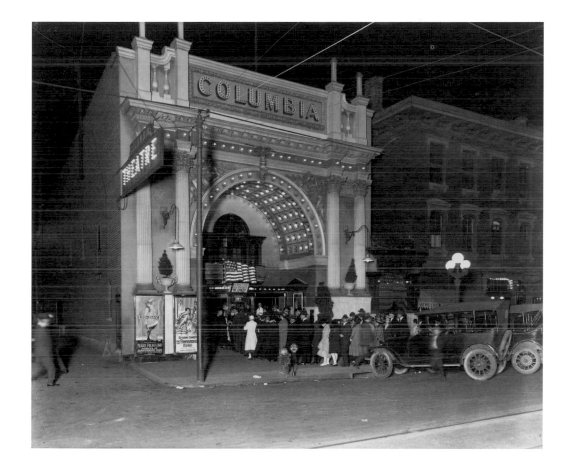

35 Dain Tasker

Daffodils in Box

1933

silver print from X-ray

28.6 x 23.5 cm (11 ¼ x 9 ¼")

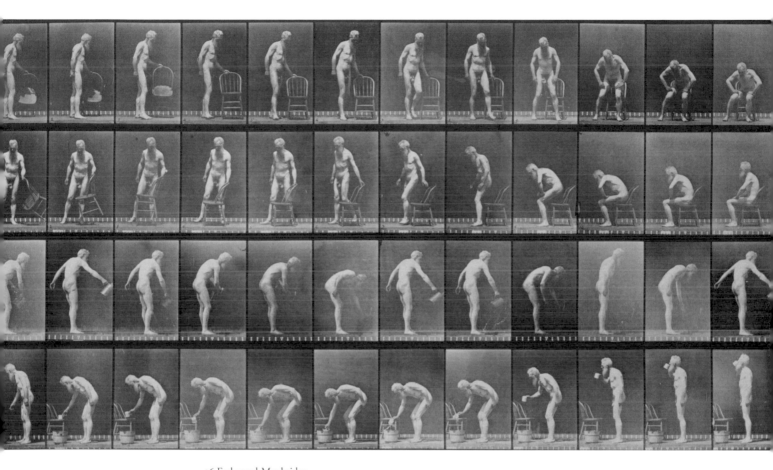

36 Eadweard Muybridge

Self-portrait Sequence from

Animal Locomotion

Published by J. B. Lippincott with

781 Plates, University of Pennsylvania

1887

collotype print

48.3 x 61 cm (19 x 24″)

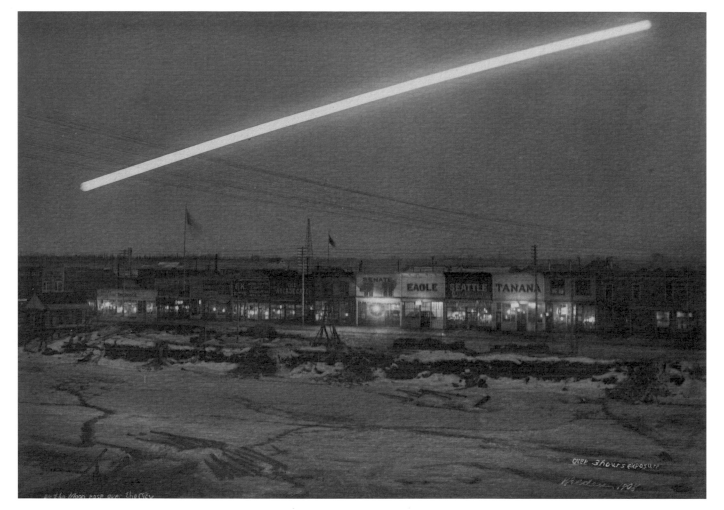

37 Welden

Moon over Fairbanks, Alaska

3 hour exposure

1908

silver print

20.3 x 25.4 cm (8 x 10")

38 Lewis Morris Rutherfurd

Six Exposures of an Eclipse

1860s

albumen print

each 11.4 x 11.4 (4 ½ x 4 ½")

Rutherfurd had an observatory
in Manhattan, New York on the corner
of Second Avenue and 11th Street.

ALL MEN
ARE CREATED
EQUAL

39 Gertrude Käsebier

Portrait of Lincoln

1923

platinum print

35.6 x 25.4 cm (14 x 10")

Käsebier copied a small photograph
of Lincoln her son found in an
abandoned trunk. She softened
Lincoln's features and printed the
photograph in platinum. It appeared
on the cover of the February, 1929
New York Times Magazine.

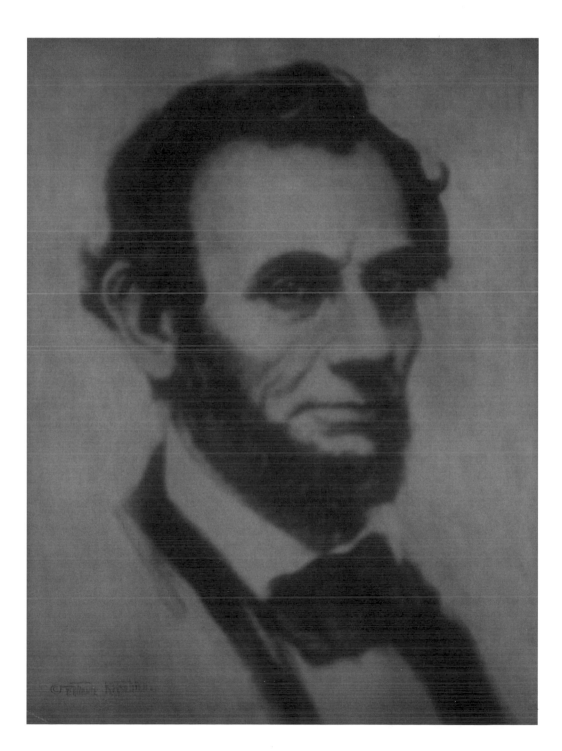

**ALL MEN
ARE CREATED
EQUAL**

Charles Dickens wrote in 1842 that the Republican institutions of America led the people to assert their self-respect and their equality. Abraham Lincoln is the President who first comes to mind when using catchwords such as self-respect, equality and freedom for all.

The photographer Gertrude Käsebier copied, enlarged and retouched the negative of a carte-de-visite of Lincoln. The platinum process softened the lines of his face and created a gentler image for the 20th-century. Käsebier's Lincoln appeared on the cover of a *New York Times Magazine* in 1929 (pl.39).

The quest for freedom is visually expressed in a composite photograph from 1865 of the signers of the Emancipation Proclamation (pl.43). Reissued in the 1880s, this photograph was sold by veterans of the Civil War to help them through hard times.

The heavy losses of the Civil War are foreboded in a rare photograph of father and son, the Johnsons, and their neighbor leaving for war (pl.40). A photograph of the Tomb of the Unknown Soldier at Arlington is honoring those who died fighting for their country (pl.41). The 100 year old Uncle Ben and his seventh wife becomes a reminder of the freedoms won by the North (pl.53).

Fourth of July parades started in 1777, the year after the signing of the Declaration of Independence (pl.46). The swearing in of presidents occasioned public and symbolic celebrations (pl.42). Circa 1938, in Prescott, Arizona, a determined looking Mrs. Liberty no doubt came to her position through local politics (pl.45).

The founding fathers were white, male, and land owners. To make the laws of the land inclusive and equal to all Americans proved an ongoing struggle. Unions opened doors for fair treatment of workers, and between the years of 1890 to 1940 workers fought for the right to unionize (pl.47). A miners' strike such as the one in Butte, Montana, home of the largest copper mines in the country, caused the militia to be called in to keep order (pl.48). Extremist groups, like the American Nazi Party, challenged concepts of democracy by testing first amendment rights (pl.44).

The view of the Boston Common by the renowned photographer, Josiah J. Hawes, represents one of the earliest expressions of the democratic paradigm (pl.49): 48 acres set aside in 1634, for the use of all the people, by the city commissioners. Nevertheless, blacks were barred from celebrating the Artillery Election, held on the Commons, following election of the new governor each year in the 18th-century.

Every American child is entitled to an education. However, this right often remained reserved for the elite and growing middle class. Education stayed subordinate to harvest season, family economics, and other such interferences. The American factory system began in 1790. Samuel Slater, an English immigrant who created the first factory, employed workers between the ages of seven and twelve. The child laborers, seven boys and two girls, came from the best families in Providence, Rhode Island.

The use of child labor was common for the next 140 years. A group of young native Alaskans by the Lomen Brothers makes you wonder about their harsh lives (pl.54). In contrast, the young women at Mills College, shot by Eadward Muybridge circa 1870, represented the elite families of their day (pl.50). The students of science at Throop, better known today as Caltech, also embodied privilege (pl.51).

An adult class for art students proves that, even a 100 years ago, anything was possible (pl.52). A good measure of our self-respect and equality can be traced to our Republican ideas as well as the educational institutions of America.

40 Unidentified

The Johnson Men Leave for War

Connecticut

circa 1861

albumen print

22.9 x 27.3 (9 x 10 ¾")

41 J. F. Jarvis, Publisher (attributed)

Tomb of the Unknown Soldier

Dedicated 1866

Arlington, Virginia

circa 1889

albumen print

21.3 x 32.4 cm (8 ⅜ x 12 ¾")

42 J. F. Jarvis, Publisher (attributed)

Swearing in of President Cleveland

Washington D.C.

1885

albumen print

21.6 x 31.1 cm (8 ½ x 12 ¼")

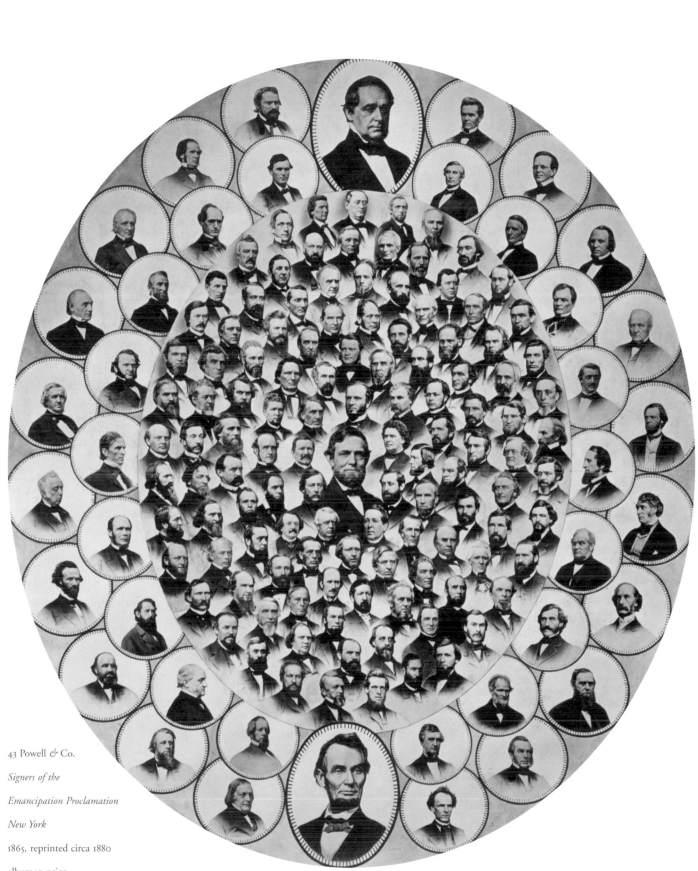

43 Powell & Co.

Signers of the

Emancipation Proclamation

New York

1865, reprinted circa 1880

albumen print

35.6 x 30.5 cm (14 x 12")

The reprint was sold by Civil War

veterans to help them financially.

44 Otto Hagel

American Nazi Rally

Hackensack, New Jersey

1939

silver print

31.8 x 26 cm (12 ½ x 10 ¼")

America's tolerance for extremist
groups ran out even before the Second
World War began.

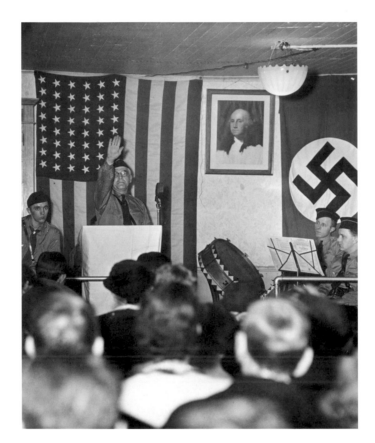

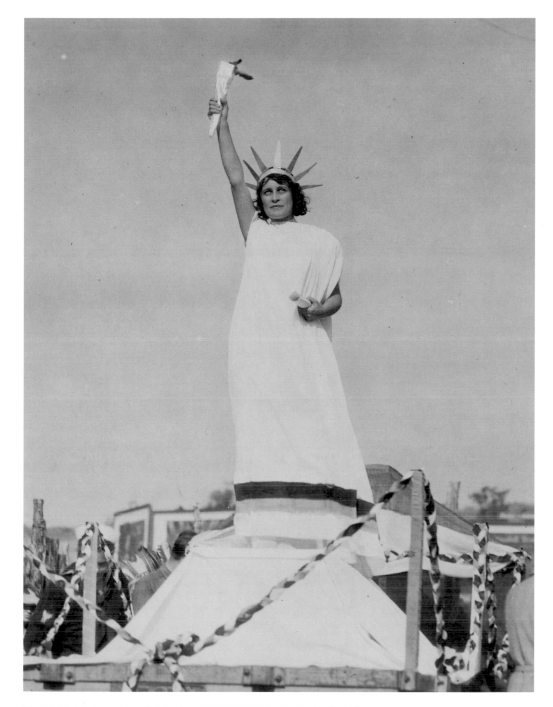

45 Underwood

Mrs. Liberty

Prescott, Arizona

circa 1938

silver print

25.4 x 20.3 cm (10 x 8")

46 Unidentified

Parade

Champaign, Illinois

circa 1865

albumen print

33 x 42 cm (13 x 16 ½")

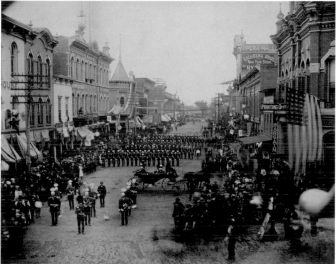

47 Hansel Mieth and Otto Hagel

Organizing Ford Workers

Detroit, Michigan

1940

silver print

26.7 x 34 cm (10 ½ x 13 ⅜")

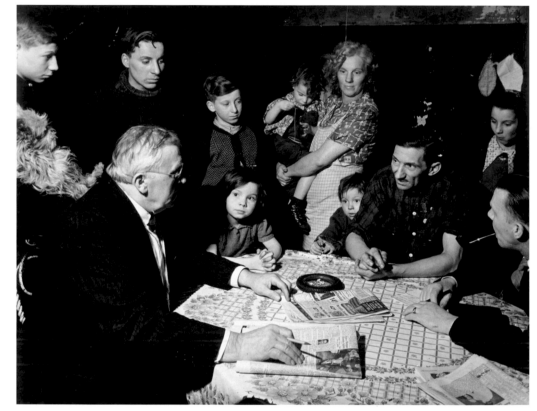

48 Unidentified

Militia Intervention in Miners' Strike

Butte, Montana

circa 1918

silver print

16.5 x 21.6 cm (6 ½ x 8 ½")

Butte, Montana was a
center for mining copper as well
as other minerals.

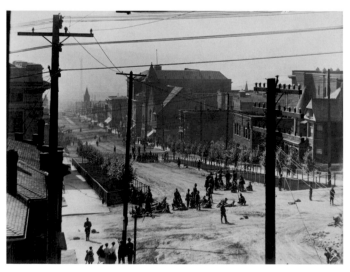

49 Josiah J. Hawes

Boston Common

Massachusetts

circa 1870

albumen print

34.3 x 28.6 cm (13 ½ x 11 ¼")

The Boston Common, 48 acres in the center of the city, became public domain in 1634. It was used as a militia training ground and pasture land until 1833.

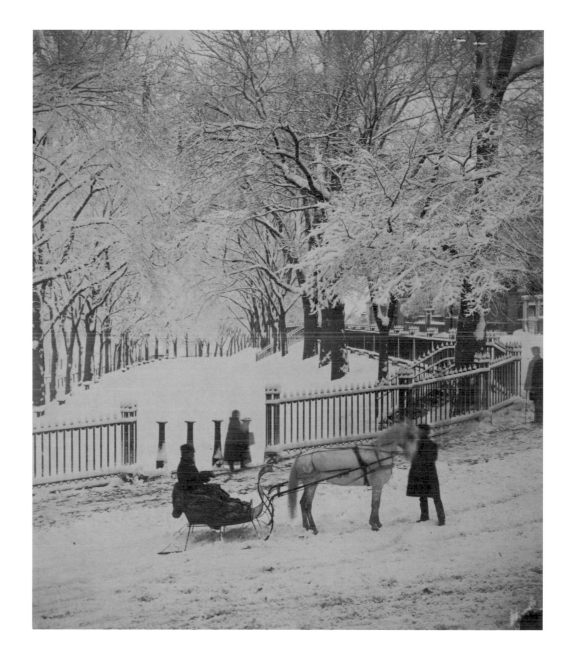

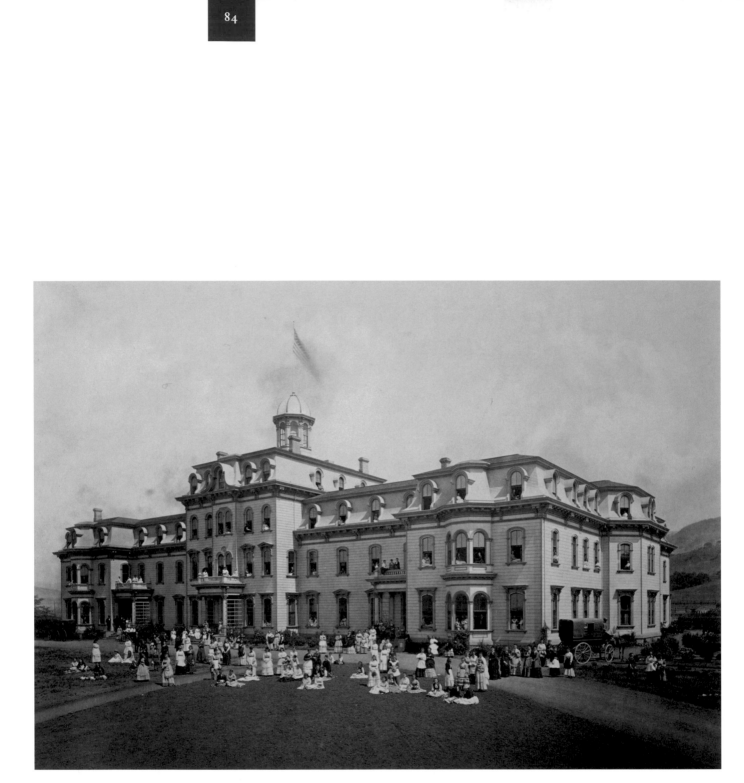

50 Eadweard Muybridge

Mills Seminary College

Oakland, California

circa 1870

albumen print

38.1 x 54 cm (15 x 21 ¼")

51 Unidentified

Prof. McClatchin's Lab Class at

Throop (*now CalTech*)

Pasadena, California

1892

cyanotype print

15.2 x 23.5 cm (6 x 9 ¼")

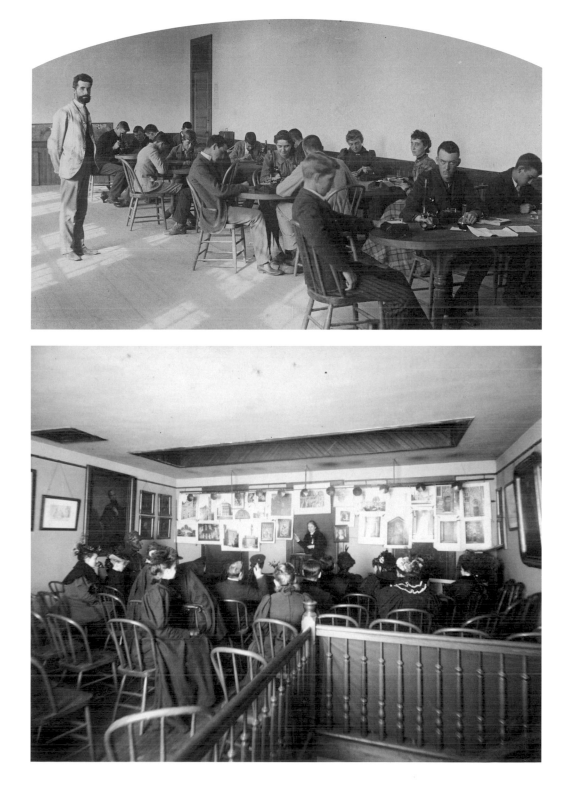

52 Unidentified

Art Appreciation Class

circa 1900

silver print

19.1 x 23.5 cm (7 ½ x 9 ¼")

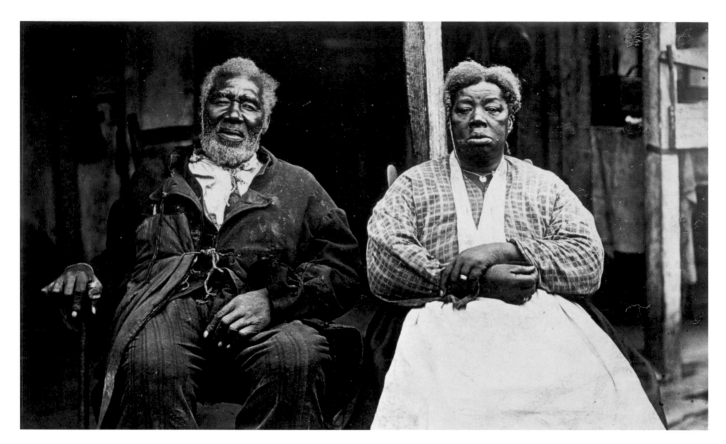

53 S. O. Dodge

Uncle Ben, 100 Years Old, and

his 7th Wife

Knoxville, Tennessee

1893

albumen print

12.1 x 20.3 cm (4 ¾ x 8")

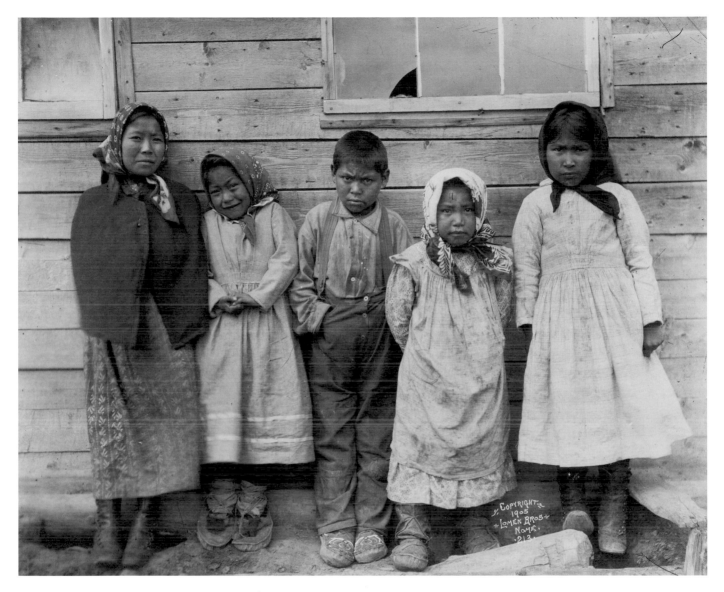

54 Lomen Brothers

Children in Front of Building

Nome, Alaska

1905

silver print

19.1 x 23.5 cm (7 ½ x 9 ¼")

The Lomen Brothers exported reindeer

meat and ran a drug store, as well as a

photography studio.

MEN
TO MATCH MY
MOUNTAINS

55 Dryden's Photo Shop

Mount Rushmore

South Dakota

circa 1940

hand-colored silver print

28 x 35.6 cm (11 x 14")

In *American Notes* Charles Dickens asserts that it would be well if the American people loved the "real" less and the "ideal" somewhat more.

George Washington was beloved in every sense of the word. In 1783, after defeating the British, our new nation asked him to be King. Washington refused, and the leaders of the day met the next year to draft the Constitution. George Washington, personifying the first real and ideal American, seems then and now the man to match Mt. Rushmore (pl.55).

During the 1860s, photographs of generals, actors, writers and politicians were placed next to pictures of relatives and friends in family albums. Circa 1870, an unidentified woman went so far as placing a representation of herself in the center of a collage circling it with cut-out pictures of family members as well as woodcuts and photographs of famous and unknown people of the day (pl.57).

Buffalo Bill came to symbolize the myth of the Wild West. He made a fortune taking his show around the states and Europe. During the 1889 Paris Exposition, when the Eiffel Tower was newly completed, Buffalo Bill proved a major attraction in the Indian Village. T. Luguer, a visitor with a Kodak camera, captured the icon leaving the village. Luguer had the 3 ½ inch round Kodak print enlarged to almost double the size (pl.67).

We love our outlaws most of all. Jesse James, like other outlaws of his day, was photographed rather infrequently. Short of money, Jesse may have been willing to pose - for pay - in the studio of the San Francisco photographer, Charles Cramer circa 1875 (pl.59). Cramer's logo on the back of the photograph is rare and identifies the image as an original. Pirated and copied photographs of outlaws never identified the photographer. Several decades later, the sixteen year old Ernest Hemingway shows all the determination and grit of a western outlaw (pl.72).

Evelyn Nesbit nearly achieved Marilyn Monroe cult status in her day. As the "girl on the red velvet swing," she became the center of a jealous rage that drove her crazed husband, Harry Thaw, to murder Stanford White, the great architect. A photograph by Strauss-Peyton, taken in 1920, some fifteen years after the shooting, shows Nesbit on tour in Kansas City (pl.71).

Samuel Morse, most famous for his invention of the telegraph, was also a portrait painter of
eminent Americans and a founder of the National Academy of Design. In 1839, he met
Daguerre and became instrumental in introducing the daguerreotype to America. An early, salt
print of Samuel Morse may have been made by a woman photographer, Mrs. Goodrich,
in Poughkeepsie (pl.62). A photograph was taken of a tribute to Columbus; his likeness cast in
silver for the 1892 Columbian Exposition celebrating the 400 year anniversary of the achievements
of the explorer (pl.56).

The Golden Spike ceremony, uniting the country for the first time by rail, produced a number of
memorable photographs (pl.60). Most were made by the well known Civil War photographer,
A. J. Russell. Another photographer recorded Alexander Graham Bell's first long distance call from
New York to Chicago in 1892 (pl.63). A member of a lifesaving team, John Daniels, became the first
person to photograph an airplane in flight when he caught Orville Wright taking off December 17,
1903 (pl.68). Later, Amelia Earhart (pl.70) and Charles Lindbergh (pl.69) became national heroes
in the history of flight.

Sarah Bernhardt, posing with her traveling entourage, created a double icon when caught by
the camera in front of a frozen Niagara Falls (pl.65). George Fiske spent his whole adult life as a
photographer in Yosemite Park (pl.66).

Because of photography, the lines between the real and the ideal blurred right in front of our eyes.
Both men and mountains appeared somewhat grander or smaller - or simply different - after the
invention of photography.

56 Unidentified

Casting a Silver Statue of Columbus

for the Columbian Exposition

Chicago, Illinois

circa 1891

photogravure print

24.8 x 30.5 cm (9 ¾ x 12")

57 Unidentified

Photo-collage

(including famous Americans)

Eastern United States

circa 1870

albumen print

35 x 50.8 cm (13 ¾ x 20")

58 James Wallace Black

Kit Carson

1867

albumen print

29.2 x 22.2 cm (11 ½ x 8 ¾")

*This was the last picture taken
of Kit Carson. He died on his way
home from the east coast.*

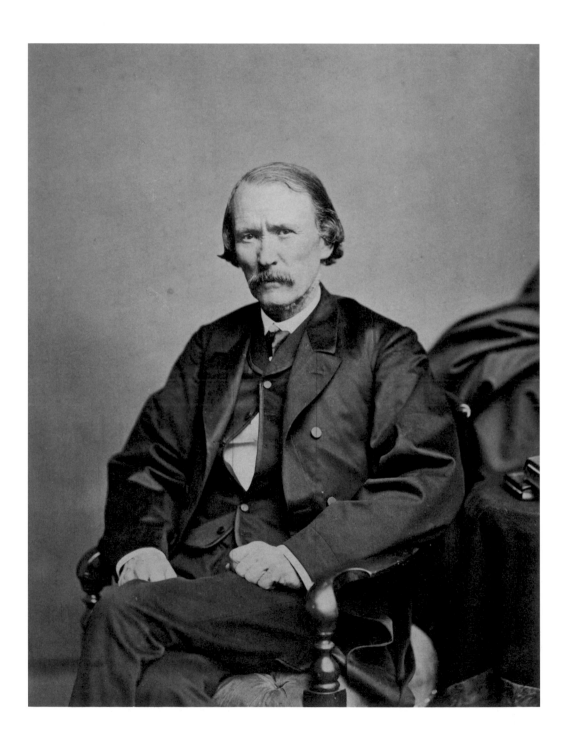

59 Charles Cramer

Cramer's California Gallery

Jesse James

circa 1875

albumen print

14.6 x 10.2 cm (5 ¾ x 4")

60 A. J. Russell

Golden Spike Ceremony

with Flag and Camera

Promentory Point, Utah

May 10, 1869

albumen print

23.5 x 30.5 cm (9 ¼ x 12")

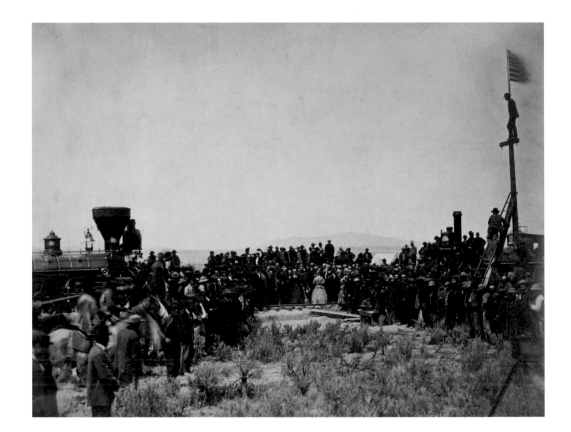

61a, b, c John Doughty

Balloon Flight

Winsted, Connecticut

1885

albumen prints

each 11.4 x 19.7 cm (4 ½ x 7 ¾")

Doughty made the first photographs
in America from a moving balloon.

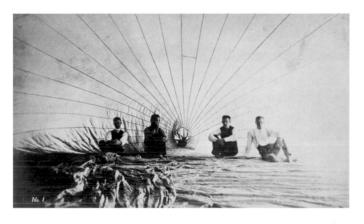

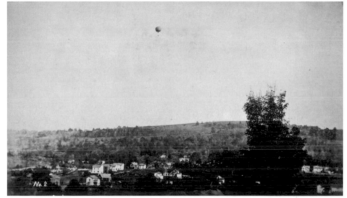

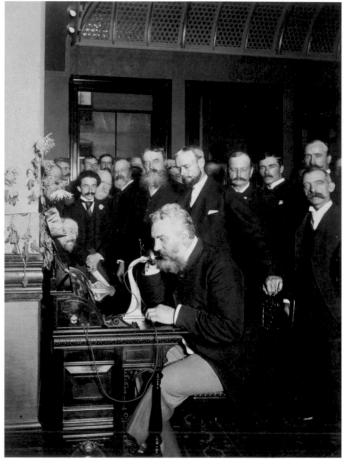

62 C. G. Goodrich (attributed)

Samuel Morse

Poughkeepsie, New York

circa 1855

salted paper print

21 x 15.9 cm (8 ¼ x 6 14")

63 Unidentified

Alexander Graham Bell Opening Long

Distance Phone Line from New York to

Chicago

1892

albumen print

26.4 x 19.1 cm (10 ⅜ x 7 ½")

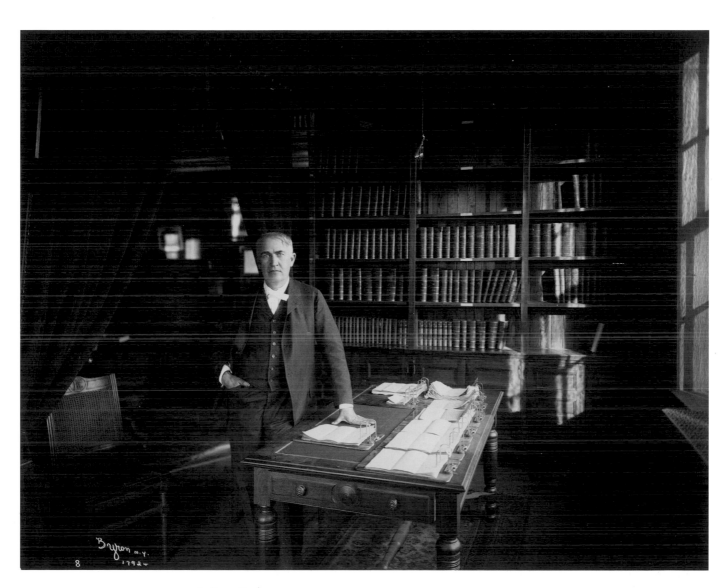

64 Byron Brothers

Thomas Alva Edison in his Lab

West Orange, New Jersey

circa 1905

printing-out paper print

19.1 x 24.1 cm (7 ½ x 9 ½")

65 Unidentified

Sarah Bernhardt and

Touring Company

Niagara Falls, New York

1906

silver print

16.5 x 17.8 cm (6 ½ x 7")

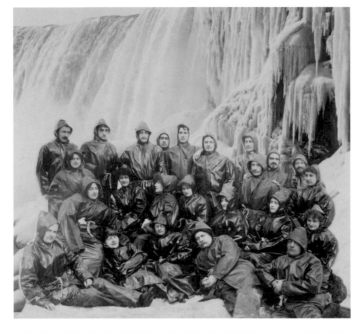

66 George Fiske

Storm from Old Ferry Bend

Yosemite, California

circa 1910

silver print

25.4 x 33 cm (10 x 13")

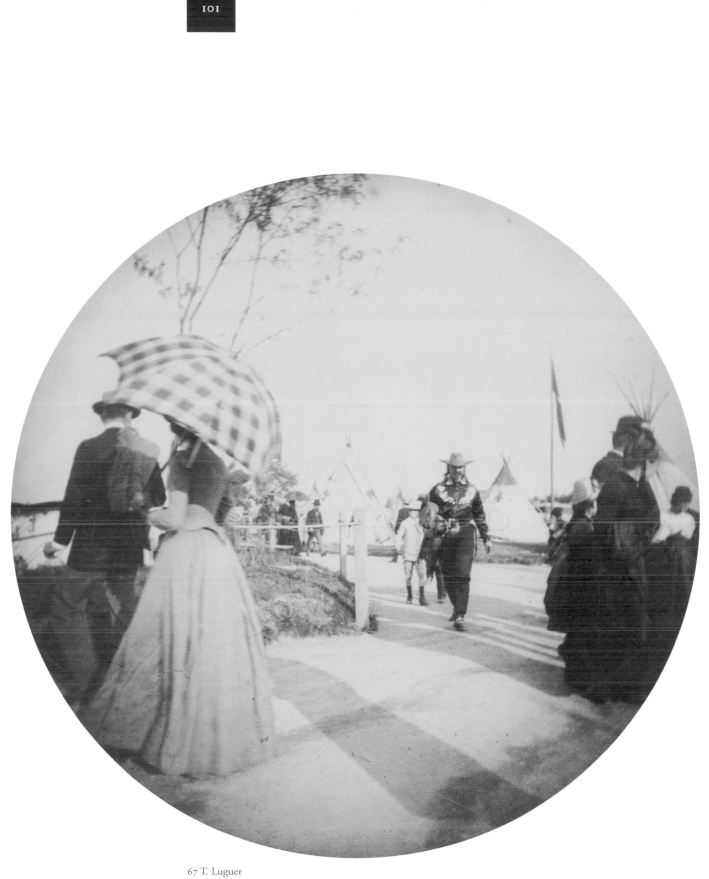

67 T. Luguer

Buffalo Bill at 1889 Paris Exposition

France

1889

toned silver print

15.2 cm (6" round)

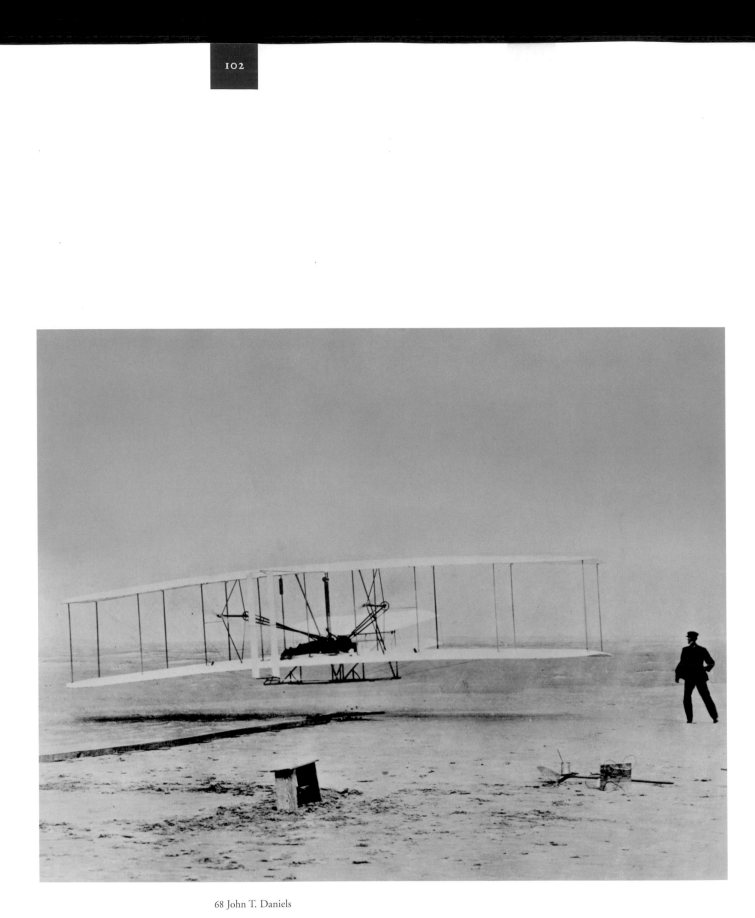

68 John T. Daniels

First Flight by Orville Wright

Kitty Hawk, North Carolina

10:35 am, December 17, 1903

silver print

20.3 x 25.4 cm. (8 x 10")

69 Unidentified

Charles Lindbergh

and the Spirit of St. Louis

circa 1928

silver print

27.9 x 35.9 cm (11 x 14 ⅛")

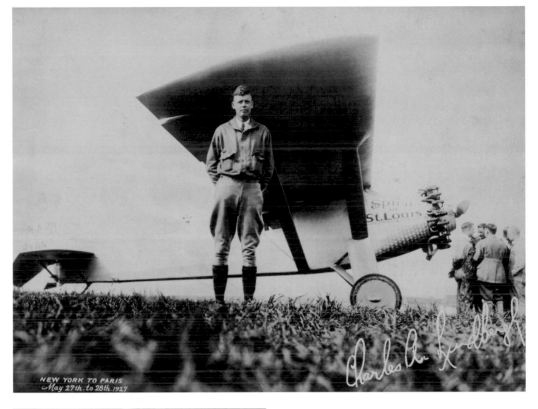

70 Acme Photos

Amelia Earhart

circa 1935

silver print

19.1 x 13.3 cm (7 ½ x 5 ¼")

71 opposite, Benjamin Strauss
and Homer Peyton
Portrait of Evelyn Nesbit
Kansas City, Missouri
1920
silver print
36.8 x 26.7 cm (14 ½ x 10 ½")

The "Girl in the Red Velvet Swing"
was on the Vaudeville circuit in 1920.

72 Unidentified
Ernest Hemingway at Age 16
Oak Park, Illinois
1916
toned silver print
25.4 x 20.3 cm (10 x 8")

73 Unidentified

Listening to KDKA *on an "Aeriola*
Junior" Receiver

Turtle Creek, Pennsylvania

1921

silver print, printed circa 1930

29.2 x 35.6 (11 ½ x 14")

KDKA, *the first radio station in the*
country, began transmitting from
Pittsburgh, Pennsylvania in 1920.

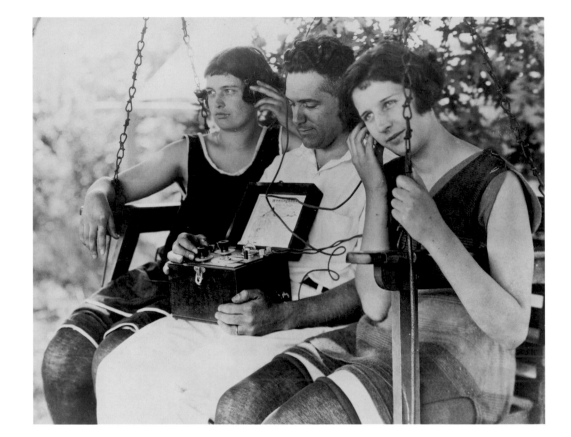

74 John Albok

First Television Transmission

to Private Homes

World's Fair, New York

1939

silver print

29.2 x 26.7 cm (11 ½ x 10 ½")

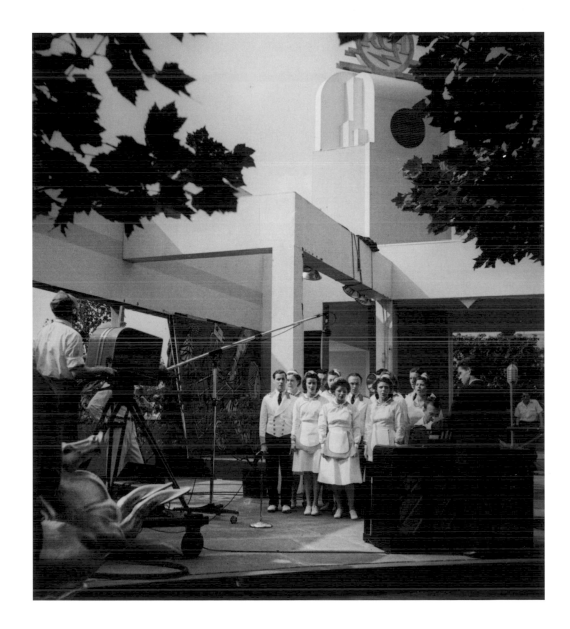

MANUFACTURING
THE DREAM

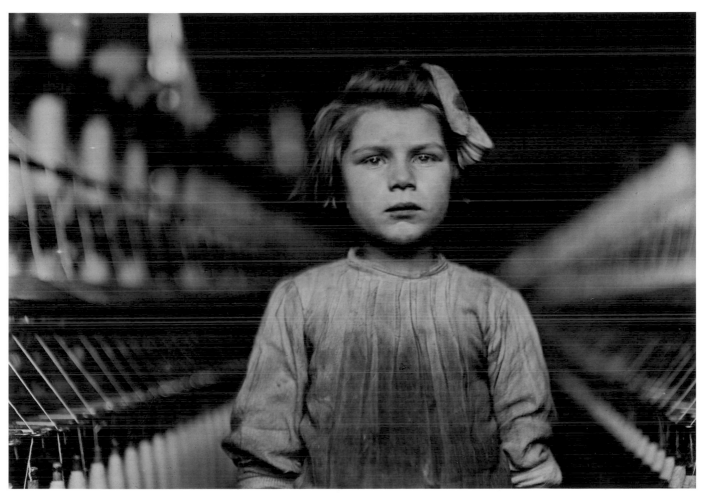

75 Lewis Hine

Spinner, Cotton Mill,

Augusta, Georgia

1909

silver print

11.4 x 16.5 cm (4 ½ x 6 ½")

Charles Dickens said of the factories in Lowell, Massachusetts that they belonged to what the English should term a Company of Proprietors, but what they call in America a Corporation.

We, in America, are blessed with an abundance of natural resources: oil, coal, natural gas, copper, water, gold - rich soil and expansive land. From the moment of their extraction, raw materials have been in constant demand for our unbridled national growth. They have defined the foundation of corporate opportunity. From the 1840s forward, our national expansion demanded a support infrastructure of bridges, dams, water systems, gas plants, electrical power plants, irrigation channels, phone systems and so on.

The ever moving western boundary became a signpost confirming the natural relationship between expansion and new consumers. Progress demanded continuously updated equipment. In the 1850s, Montgomery Meigs was responsible for bringing a water system into Washington D.C. (pl.76). Oil Creek (pl.79) became the center of the first oil strike in America. Pennsylvania for many years led the way in oil production.

Before oil overtook coal as an energy source, coal was feverishly produced at the Susquehanna Coal Company (pl.83). Breaker boys worked in the dust and grime sorting coal from slag (pl.84). Natural gas began to find its way into the workplace as well as the home (pl.82). Workers became in great demand on projects such as Hoover Dam; an enormous engineering feat employing thousands (pl.78). Building the Bay Bridge required a huge labor force. Yet, a worker on the bridge still took the time to make photographs of his friends (pl.102a-c).

Men and women of all ages worked endless hours, and farmers toiled the land from dawn to dusk. The land hummed with life while factories sucked the youth out of our children (pl.75). At times, however, companies did provide a good income, security and dignity for their workers (pl.90). Sweat shops provided jobs for immigrant women (pl.98). The sweat of laborers became the necessary ingredient of the fashion industry (pl.100). Without regulation, the workers in sweat shops were commonly subjected to terrible conditions. Sometimes, workers paid with their lives such as the 146 immigrant women and girls of the Triangle Shirt Waist Fire in 1911 (pl.99).

Manufacturing plants were going day and night (pl.85). Steel became the foundational structure of our cities (pl.86). The Colt Manufacturing Co., on the other hand, shaped steel into an unlimited supply of guns abetting our natural propensity for violence (pl.87). The military funded grand projects to aid in the United States expansion (pl.89).

New products, produced by large and small manufacturers and refiners, became the newfound comforts and necessities for the rich and growing middle class. Sales campaigns started the promotion and advertisement of the manufacturing machine (pl.94), the glamorous dress (pl.100), the household product (pl.109), the beauty aid (pl.111), and the shiniest and most luxurious automobile (pl.113).

Fairs grew into promotional tools for selling new products (pl.107). Later these fairs expanded into gigantic commercial events where entire buildings, functioning as convention halls, were purchased by companies to market their products (pl.119). Producers and consumers alike became colluders and perpetuators of the American dream. Raw hide gears, hairpins, matches, cigars; no item was sacred and exempt from the masterminds of advertising. Window displays parroted the affluence that began to emerge in the 20th-century (pl.101). Advertising invaded our lives selling us products we did not know we wanted or needed.

In due time, we all became consummate consumers. We were bombarded with and tempted by products from fish at the market (pl.120), tobacco in a shabby country store (pl.118), and wares at a penny sale (pl.121). Ugly or beautiful, small or big, edible or inedible; the stuff was packaged and sold to us for a price we could not refuse.

In fact, so long as our pocketbooks stay as big as our eyes, so long will we have corporations offering us fancy merchandise.

76 Emory Walker (attributed)

Montgomery Meigs, Builder of the

Washington Aquaduct

Washington D.C.

1858

salt print

24.1 x 34.3 cm (9 ½ x 13 ½")

77 William Purviance

Fairmount Waterworks

Philadelphia, Pennsylvania

circa 1875

albumen print

24.8 x 33 cm (9 ¾ x 13")

78 Ben Glaha

Boulder Dam under Construction

Nevada

1934

50.2 x 40.6 cm (19 ¾ x 16")

79 H. A. Armstrong

Oil Creek, Pennsylvania

circa 1865

albumen print

19.1 x 23.5 cm (7 ½ x 9 ¼")

Armstrong worked as a civil
engineer for the Pennsylvania
and Erie Railroads.

80 Roi Partridge

Oil Wells and Pepper Tree

Signal Hill, Los Angeles?

1941

silver print

26.4 x 31.1 cm (10 ⅜ x 12 ¼")

Partridge was the husband of
Imogen Cunningham. He taught at
Mills College in Oakland, California.

81 William Rau

Lattimer Colliery

Pennsylvania

circa 1890

albumen print

43.2 x 52.1 cm (17 x 20 ½")

82 Amy Whittemore

Gas Plant at Night

circa 1920

platinum print

21.3 x 16.2 cm (8 ⅜ x 6 ⅜")

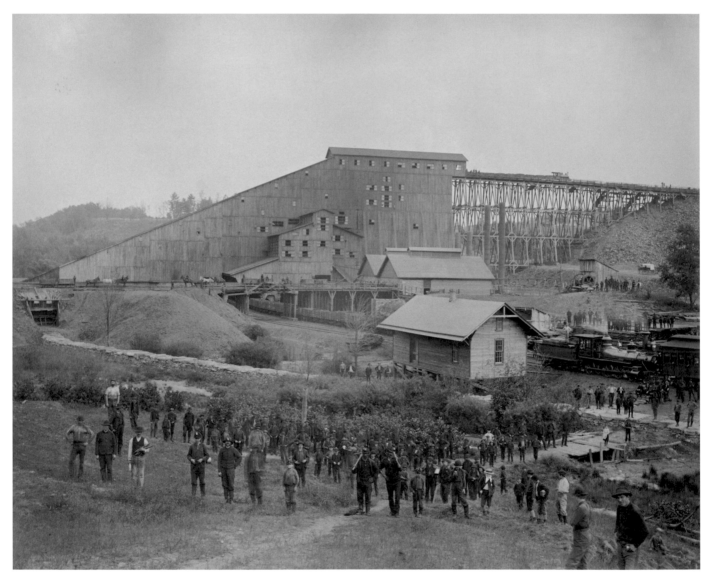

83 C. F. Cook

Susquehanna Coal Company

Pennsylvania

circa 1870

albumen print

43.5 x 54 cm (17 ⅛ x 21 ¼")

84 Lewis Hine

Coal Breaker Boys

Pittston, Pennsylvania

1910

silver print

20.3 x 25.4 cm (8 x 10")

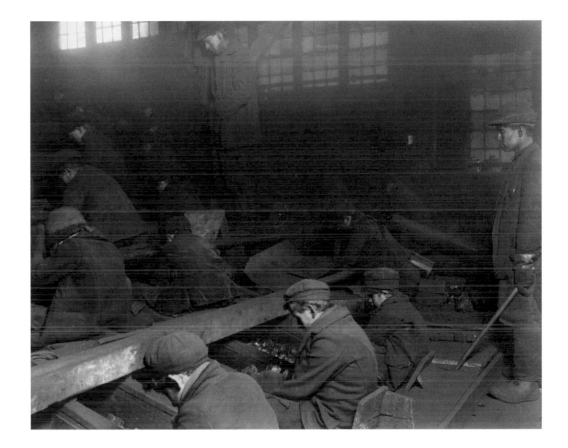

85 Lewis Hine

Pittsburgh Steel Plant at Night

Pennsylvania

circa 1935

toned silver print

32.4 x 46.4 cm (12 ¾ x 18 ¼")

86 Fred G. Korth

Pouring Ingots

Chicago, Illinois

circa 1935

silver print

48.9 x 38.4 cm (19 ¼ x 15 ⅛")

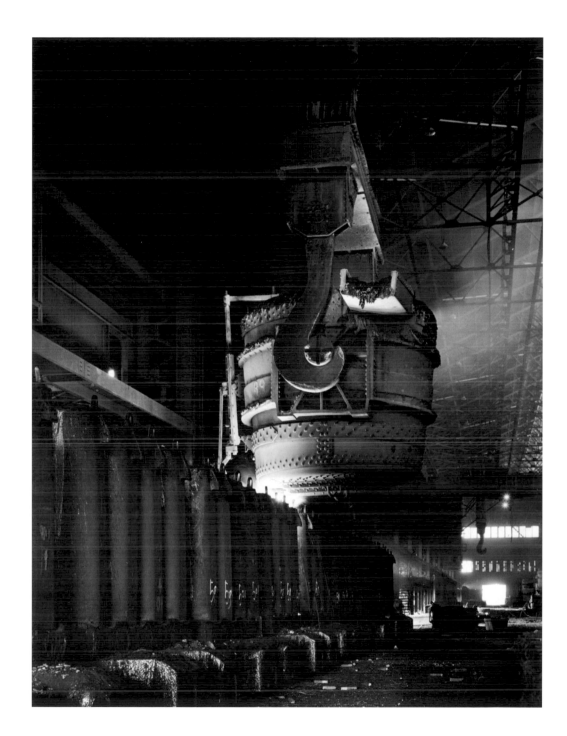

87 Prescott & White

Colt Manufacturing Co.

Hartford, Connecticut

circa 1860

albumen print

38.1 x 48.9 cm (15 x 19 ¼")

The Colt was the pistol of choice
in the 19th-century West.

88 Imogen Cunningham

Fageol Ventilators

California

1934, printed 1960s

silver print

18.4 x 22.9 cm (7 ¼ x 9")

©1970 The Imogen Cunningham Trust

89 Liebich

Rudder for the Battleship "Alabama"

Cleveland, Ohio

circa 1885

silver print

34.3 x 26.7 cm (13 ½ x 10 ½")

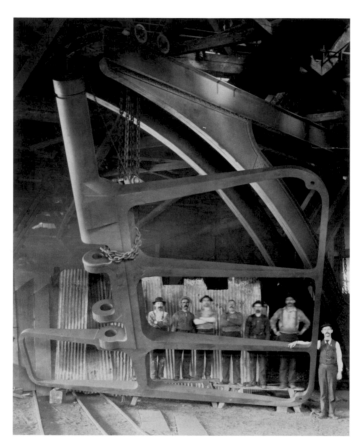

90 Jack Tham (attributed)

A. Brumbach, Textile Machine Works

Reading, Pennsylvania

1929

silver print

19.1 x 24.1 cm (7 ½ x 9 ½")

Brumbach was one of several
employees photographed to
commemorate 25 years,
or longer, of service to the
Textile Machine Works.

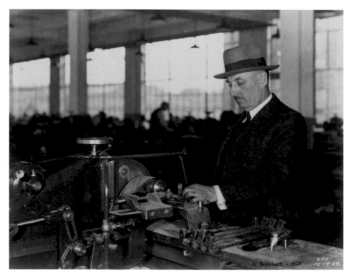

91 above, Unidentified

Oppel's Gang, Portland, Oregon

1913

silver print

16.8 x 21.6 cm (6 ⅝ x 8 ½")

92 Margaret Bourke-White

Stringing the Grand Piano

Steinway Factory

New York City

1934

toned silver print

33.3 x 23.5 cm (13 ⅛ x 9 ¼")

Bourke-White presented this
and several other of her photographs
of the factory, commissioned by
Fortune Magazine, *to Mr. Steinway.*

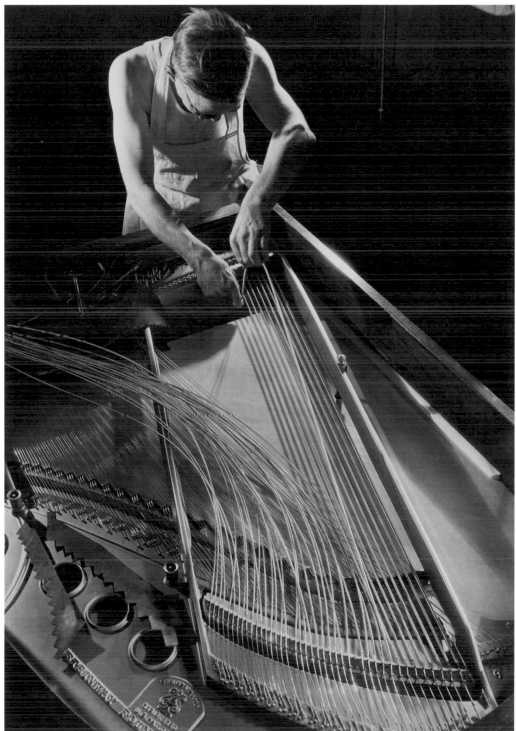

93 Unidentified

Displaying the Seller's Valve,

circa 1936

toned silver print

34.6 x 26 cm (13 ⅝ x 10 ¼")

94 Unidentified

Burdick Bolt Machine

Buffalo, New York

1872

montage, albumen print

38.1 x 29.9 cm (15 x 11 ¾")

*The cut-outs show the parts
needed to convert this machine from
making bolts to making nuts.*

95 John Hoyt

Farquhar Engine

Erie, Pennsylvania

circa 1900

printing-out paper print

19.4 x 24.1 cm (7 ⅝ x 9 ½")

96 Parkinson

Blacksmithing

1896

albumen print

50.8 x 40.6 cm (20 x 16")

97 Unidentified

Packing House Workers

West Covina, California

panorama silver print

1930s

17.8 x 43.2 cm (7 x 17")

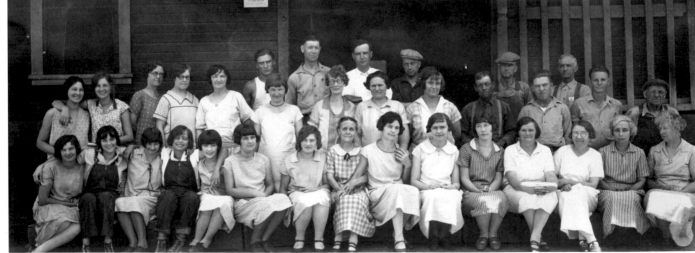

98 Victor Photo Co.

Garment Workers

New York City

1910

silver print

14 x 20.3 cm (5 ½ x 8")

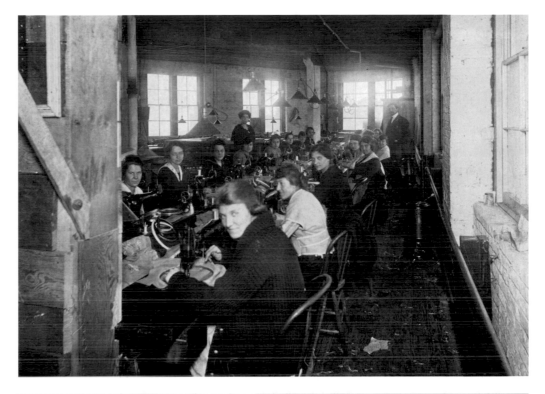

99 Brown Brothers

Identifying Triangle Shirt Fire Victims

New York City

1914

silver print

16.5 x 21.6 cm (6 ½ x 8 ½")

The last survivor of the fire,
Rose Freedman, died at age 107
in Los Angeles in 2001.

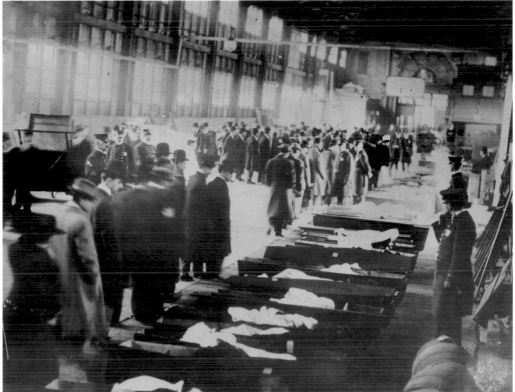

100 Edward Steichen

Two Bergdorf-Goodman Models

for Vogue

1927

toned silver print

25.4 x 20.3 cm (10 x 8")

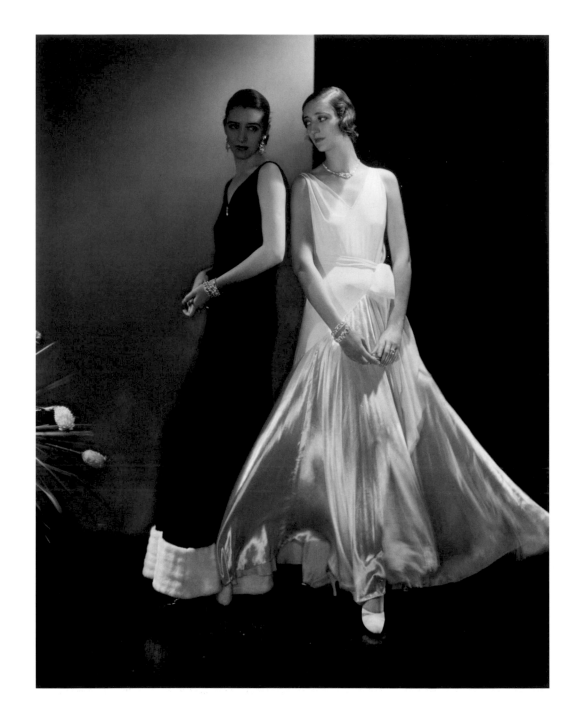

101 Unidentified

MacDougall's Display of

Grace-Tred Shoes

circa 1930

silver print

20.3 x 25.4 cm (8 x 10")

102a Unidentified Amateur

Bay Bridge Construction Workers

on a Break

San Francisco, California

circa 1935

silver print

7 x 11.4 cm (2 ¾ x 4 ½")

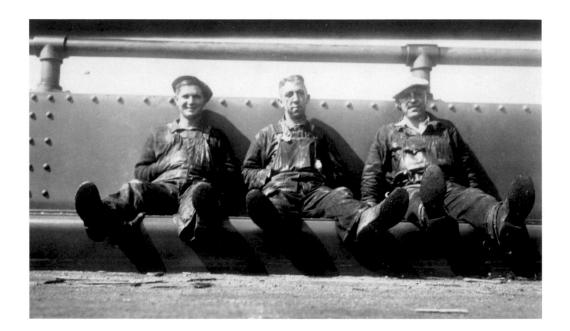

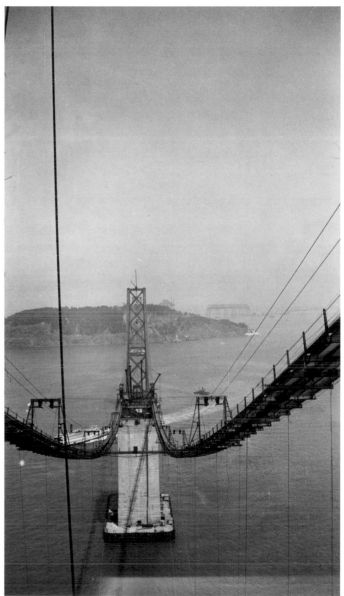

102b, c Unidentified Amateur

Bay Bridge Construction

San Francisco, California

circa 1935

silver prints

each 11.4 x 7 cm (4 ½ x 2 ¾")

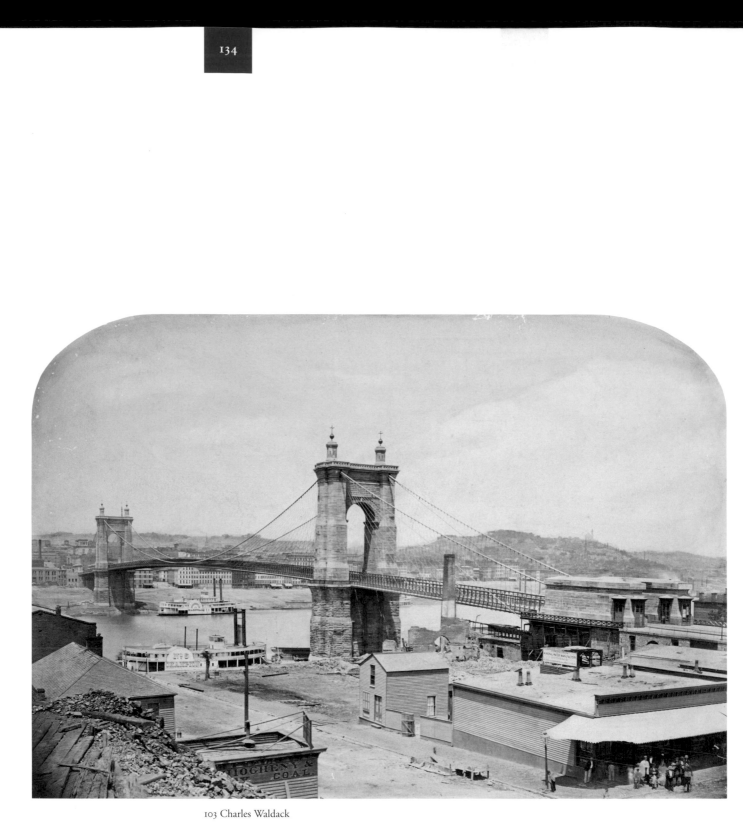

103 Charles Waldack

Cincinnati Suspension Bridge

Ohio

1867

hand-colored albumen print

27.9 x 40 cm (11 x 15 ¾")

This was the first suspension bridge

built in the United States.

104 Roger Leavitt bromoil print

Sinews of Steel 28.6 x 23.5 cm (11 ¼ x 9 ¼")

New York

circa 1935

105 Unidentified

Century Club Cigars

F. B. Richards & Co.

Binghamton, New York

circa 1900

silver print

20.3 x 15.2 cm (8 x 6")

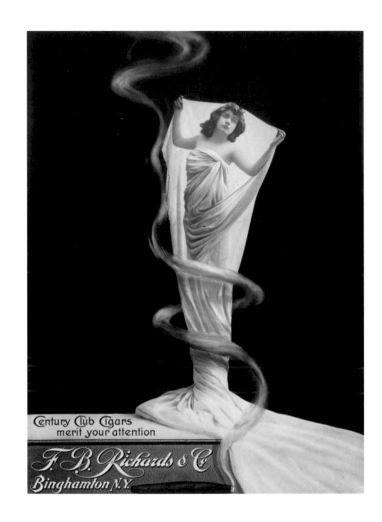

106 Anton Bruehl

CBS *Radio Transmitters Linked*

circa 1935

silver print

24.8 x 20.3 cm (9 ¾ x 8")

©Anton Bruehl/courtesy

Howard Greenberg Gallery,

New York

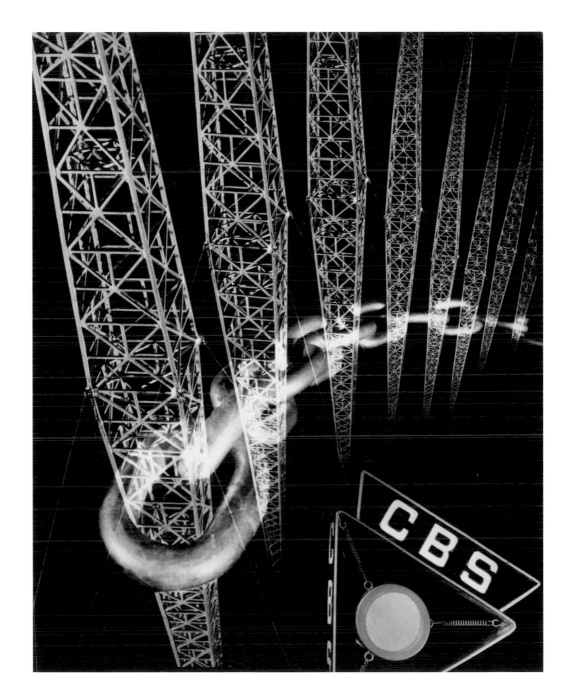

107 Elmer Chickering

Worcester Salt Lighthouse Display

Boston, Massachusetts

1897

silver print

41.3 x 33.7 cm (16 ¼ x 13 ¼")

The lighthouse is built from bags of

Worcester salt.

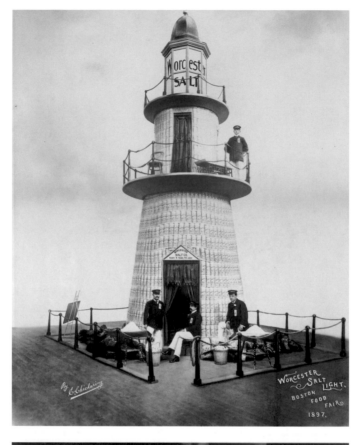

108 William Mills and Co.

Displaying a 453 Pound Raw

Hide Gear Blank at the Holbrook

Raw Hide Co.

Providence, Rhode Island

circa 1908

silver print

21 x 15.9 cm (8 ¼ x 6 ¼")

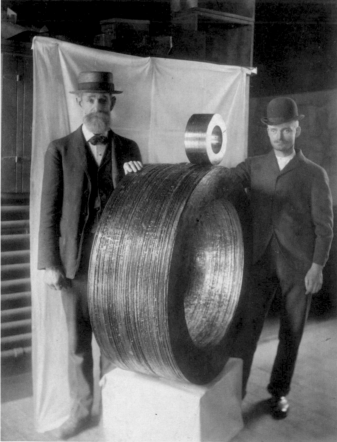

109 Unidentified

Washtub Display

circa 1900

silver print

19.1 x 22.9 cm (7 ½ x 9")

110 Ingalls

Display Window

Nashua, New Hampshire

circa 1900

printing-out paper print

18.4 x 24.1 cm (7 ¼ x 9 ½")

111 Stadler Phot. Co.

Hairpins in Display Cabinet

circa 1910

hand-colored silver print

24.1 x 29.9 cm (9 ½ x 11 ¾")

112 Will Connell

Three States of Striking a Match

Los Angeles, California

circa 1932

tricolor carbro print

22.9 x 18.4. cm (9 x 7 ¼")

113 Paul Outerbridge

Advertisement for Marmion Motor Co.

New York

circa 1920

montage, platinum print

10.5 x 23.8 cm (4 ⅛ x 9 ⅜")

114 John Collins

Puritan Products Display

1932

silver print

25.4 x 33 cm (10 x 13")

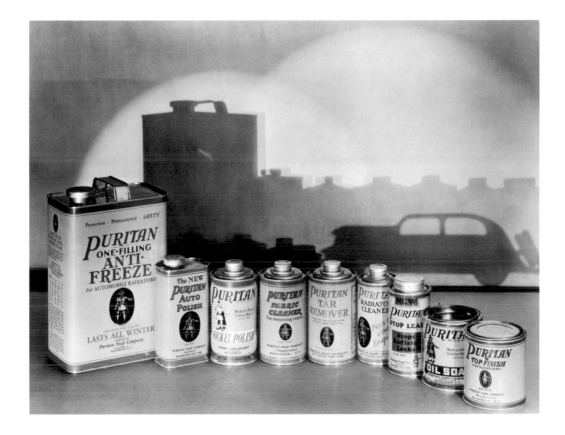

115 James Doolittle

Pipe Displayed in Empty Frame

circa 1935

tricolor carbro print

44.5 x 31.8 cm (17 ½ x 12 ½")

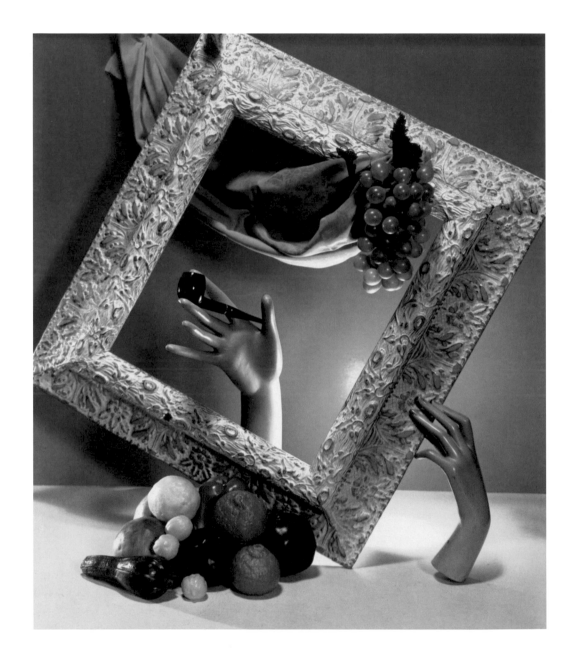

116 Fred Archer

Westinghouse Display Building

World's Fair, New York

1939

silver print

32.4 x 25.4 cm (12 ¾ x 10")

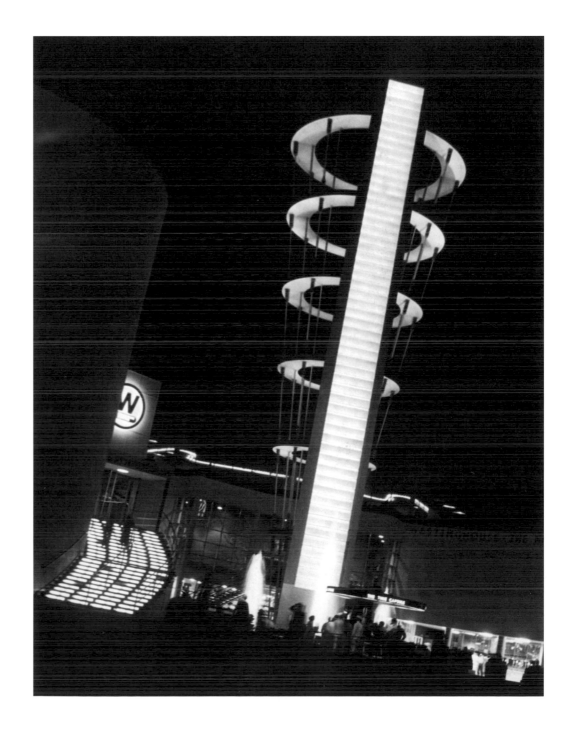

117a, b, c Unidentified

Telephone Repair in Winter

St. Louis, Missouri

circa 1935

silver prints

each 3.8 x 6.4 cm (1 ½ x 2 ½")

118 Walker Evans

Country Store Vicinity Moundville

Alabama

Summer, 1936

silver print

21 x 25.4 cm (8 ¼ x 10")

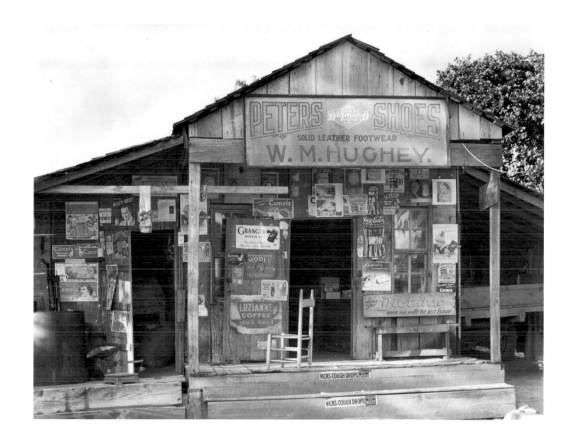

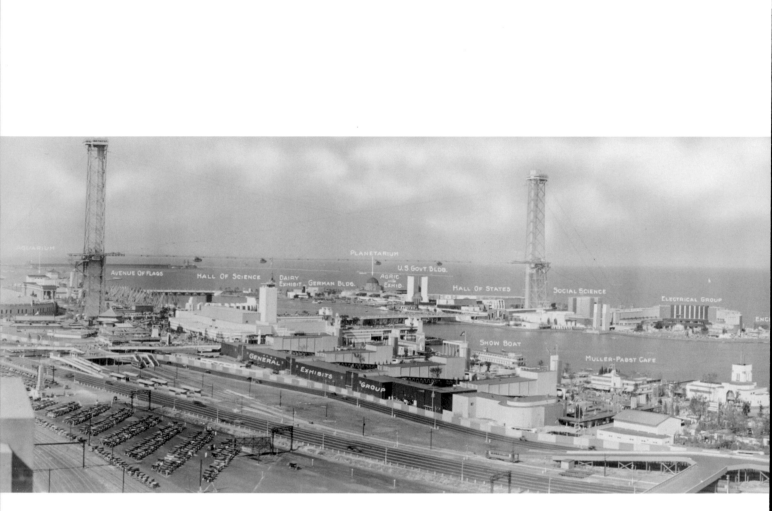

119 H. Koss

Panorama of the Century of

Progress Exposition

Chicago, Illinois

1933

toned silver print

25.4 x 152.4 cm (10 x 60")

120 W. O. Underwood

Interior of Fish Market

Boston, Massachusetts

circa 1905

charcoal gum print?

22.9 x 24.1 cm (9 x 9 ½")

Underwood was a founding member
of the Photo-Secession, and a cousin of
Alvin Langdon Coburn.

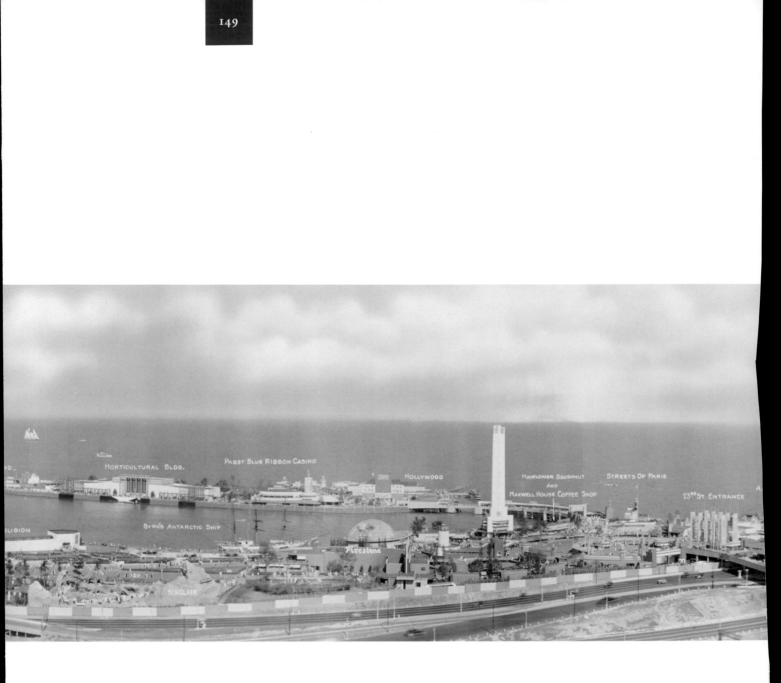

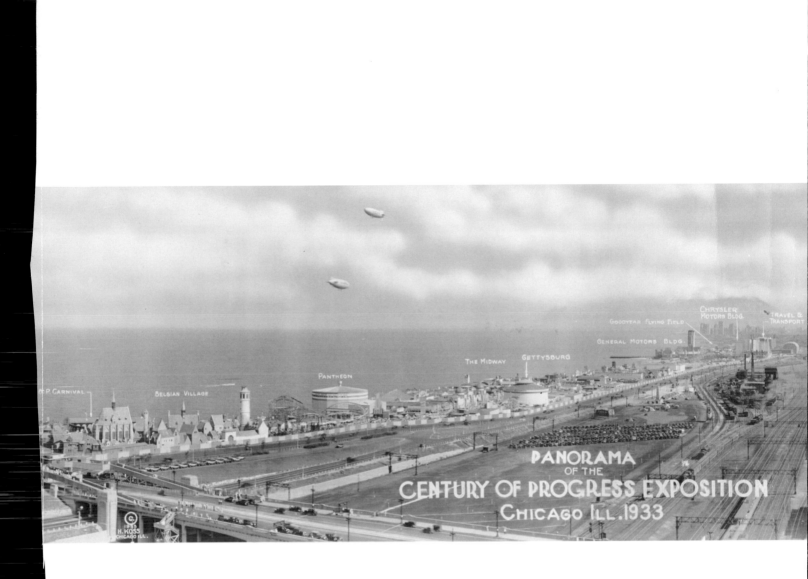

PANORAMA
OF THE
CENTURY OF PROGRESS EXPOSITION
CHICAGO ILL. 1933

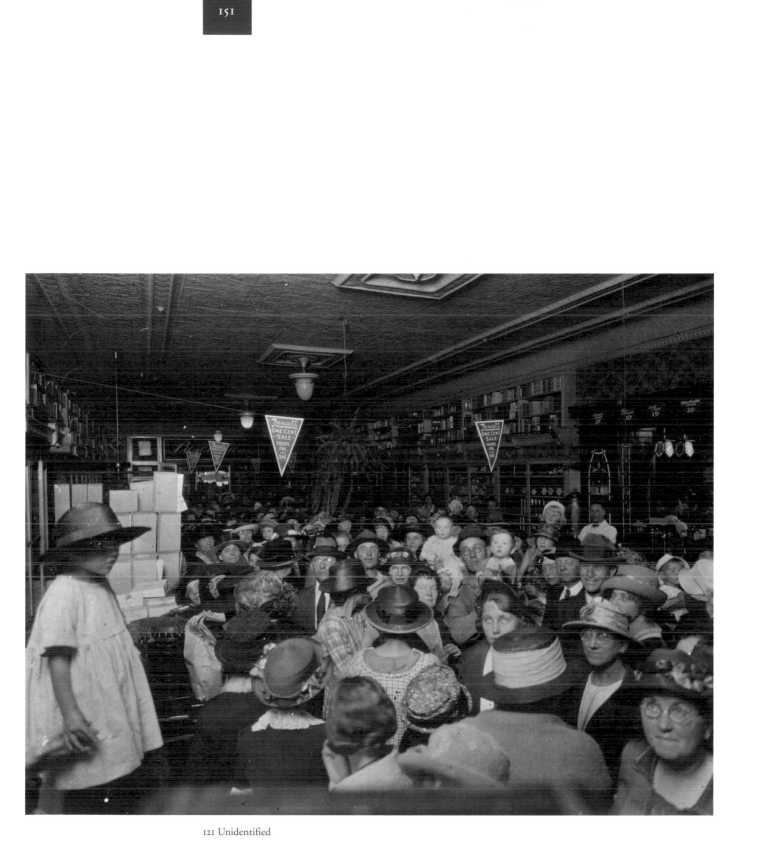

121 Unidentified

Keystone One-Cent Sale

Rexall Drugstore

Riverside, California

1921

silver print

19.1 x 24.1 cm (7 ½ x 9 ½")

NEW
FRONTIERS

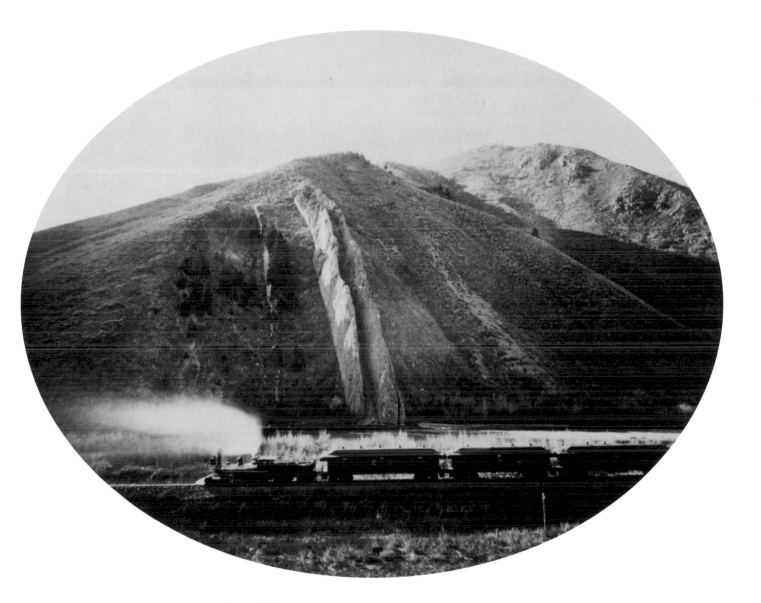

122 Carleton Watkins

The Devil's Slide

Weber Can(y)on, Utah

1878

albumen print

17.8 x 23.5 cm (7 x 9 ¼")

Charles Dickens maintained that the frontier is a land of resort and settlements of dissenters, because ground can be purchased, and towns and villages reared, where there were none of the human creation before.

The dream of religious freedom and economic rewards drew thousands of immigrants to the new land. The promise of land and glory pushed the masses toward the western frontiers. Throughout the second half of the 19th-century, new railways delivered a constant flow of immigrants to makeshift towns. Even though journeying by train could be arduous and, at times, a dangerous affair (pl.124), people kept on moving.

State after state joined the Union. As the middle class grew more affluent, the commerce of tourism expanded into the huge industry of today. Photographs showing the natural wonders of the new frontiers were collected in travel albums and sent as postcards. They attracted floods of people. Tourists made their precarious way down the Grand Canyon (pl.134), and the photographer A. C. Vroman, along with other adventurous spirits, traveled with friends from California to New Mexico to study Indian cultures (pl.133).

Travelers would stop along the way on their railway journey to admire the scenery (pl.122). Before railways, riverboats and coaches had provided the main form of transportation (pl.125). Now, the arrival of trains removed the sense of isolation that had sapped the life out of the prairie inhabitants. Before railways, supplies had been transported by wagon train all too rarely sighted (pls.128 & 129).

Geologists found the earth rich with natural resources: copper, gold, borax, silver (pl.144). Miners toiled their lives away underground (pl.145). To make a living they took great risks as witnessed in the Scofield mining disaster in Utah that killed two hundred men in 1900. Laid out in a classroom, the dead miners become a reminder of the sacrifices made in the name of progress (pl.146).

Clashes between native Americans and the United States government led to fierce battles. When D. F. Barry photographed Chief Gall in the early 1880s (pl.135a), he described him as one of the

most bloodthirsty of chiefs to attack Custer at Little Big Horn. Twenty years later, Barry published another photograph of a far more noble looking Gall (pl.135b). After seizing Geronimo's renegade band, the army escorted the Indians to trains that would carry them off to a reservation in Florida. In a poignant photograph by C. S. Fly (pl.137) we see the real Vanishing Race and not the sentimental picture offered by Edward Curtis (pl.138). Carleton Watkins photographed the dire results of industry causing American Indians literally to be out of water (pl.132).

The lumber industry cleared the hillsides of trees (pl.141). Clever immigrants used the leftover stumps for building homes (pl.142). Though pioneers could build a tabernacle in one day (pl.147a-c), forces of nature always proved faster flattening a town in just a couple of minutes (pl.148). The isolation on the prairie is apparent in a tranquil image of a North Dakota farm house with laundry flapping in the breeze (pl.149). Eight bodies were found in the cellar and barn; most of the family members murdered by a crazed neighbor.

The dawn of the 20th-century brought with it the motor car and airplane. People went crazy for cars (pl.157), and commercial airlines started, during the 1930s, to carry loads of passengers across the country (pl.154).

The railroad terminated in Los Angeles (pl.158). Here the city of the future, the city of Hollywoodland (pl.159), stretched itself across the dry and barren basin (pl.160). The banal subject of water rights became the intriguing story for Hollywood movies. Highways filled the hills and valleys with shiny new cars. Cadillacs, Fords and Oldsmobiles drove with ease from the Venice oil fields to a Topanga barbecue (pl.155).

Los Angeles remains the birthplace of our car culture and the center of the movie industry. It is a city of resort and a settlement of dissenters just because it is perfectly situated where there were none, or little, of the human creation before.

123 Unidentified

Steam Engine from Altoona Shop

Altoona, Pennsylvania

circa 1865

albumen print

27.3 x 42.6 cm (10 ¾ x 16 ¾")

124a, b, c Baker and Rowan

Wreck of the Santa Fe

January, 1913

silver prints

each 12.7 x 17.8 cm (5 x 7")

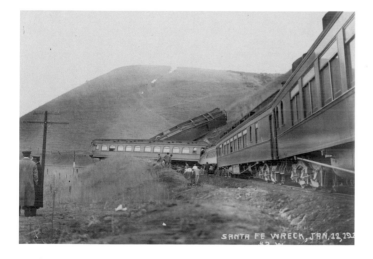

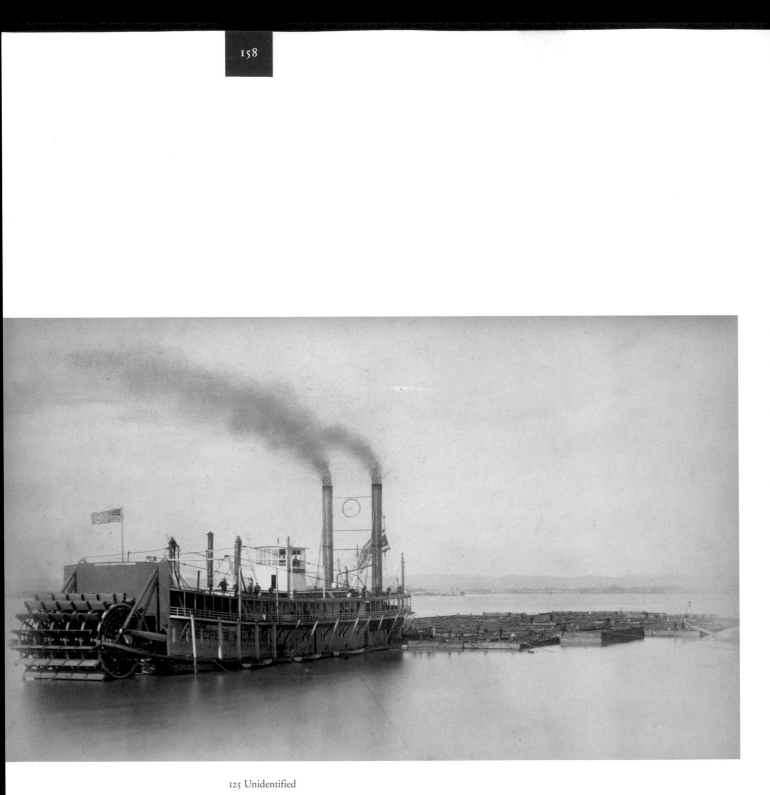

125 Unidentified

River Boat, Jos. B. Williams, *Refueling*

Pittsburgh, Pennsylvania

circa 1865

albumen print

34.9 x 55.6 cm (13 ¾ x 21 ⅞")

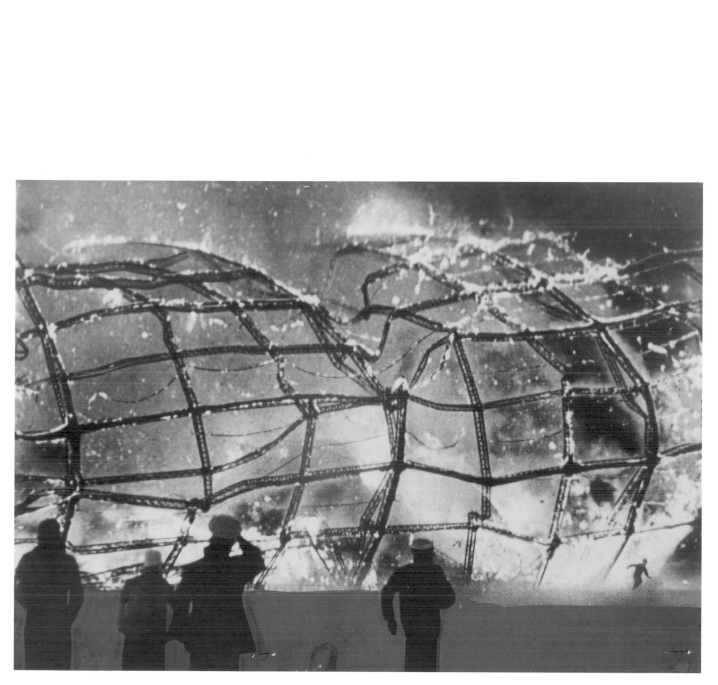

126 Unidentified

Hindenburg *in Flames*

Lakehurst, New Jersey

1937

silver print

26.7 x 43.2 cm (10 ½ x 17")

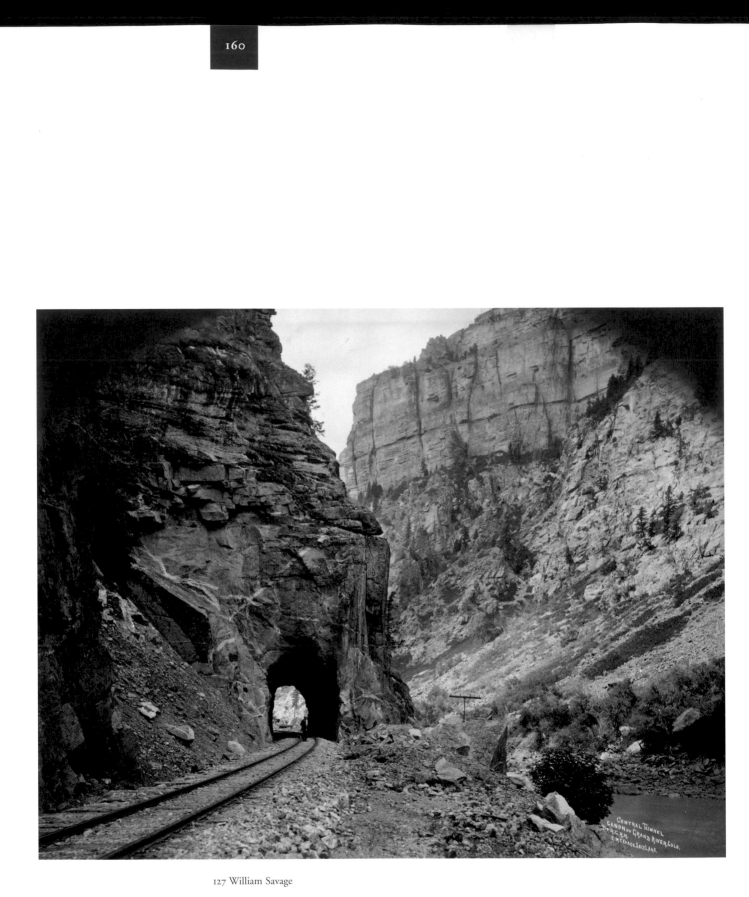

127 William Savage

Telegraph and Railroad

Utah

circa 1895

aristotype print

42 x 53.3 cm (16 ½ x 21")

128 Williams and McDonald

A Cross Country Wagon Train

Larimer Street

Denver, Colorado

June 20, 1868

albumen print

14.6 x 19.7 cm (5 ¾ x 7 ¾")

129 Laton A. Huffman

Jerk Line #12 on Old Montana

Freight Road

circa 1900

hand-colored silver print

20.3 x 50.2 cm (8 x 19 ¾")

130 Alex Martin

Engineers' Excursion

Colorado

1889

albumen print

44.5 x 54.6 cm (17 ½ x 21 ½")

131 Adolph Fassbender

Industry of the West

circa 1935

silver print

48.9 x 34.9 cm (19 ¼ x 13 ¾")

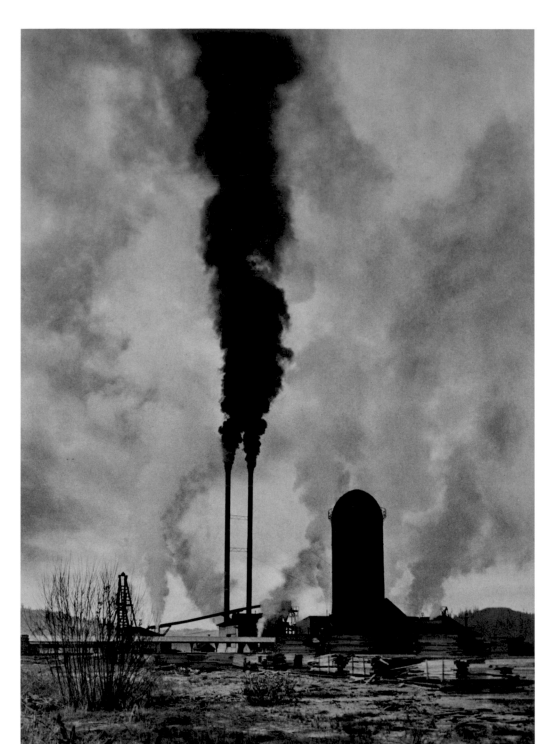

132 Carleton Watkins

Port Gamble, Washington

circa 1882

albumen print

21 x 30.5 cm (8 ¼ x 12")

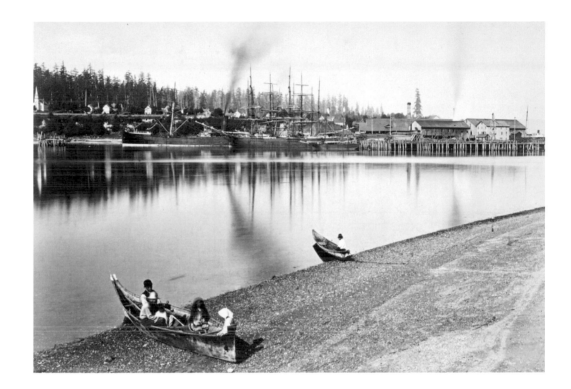

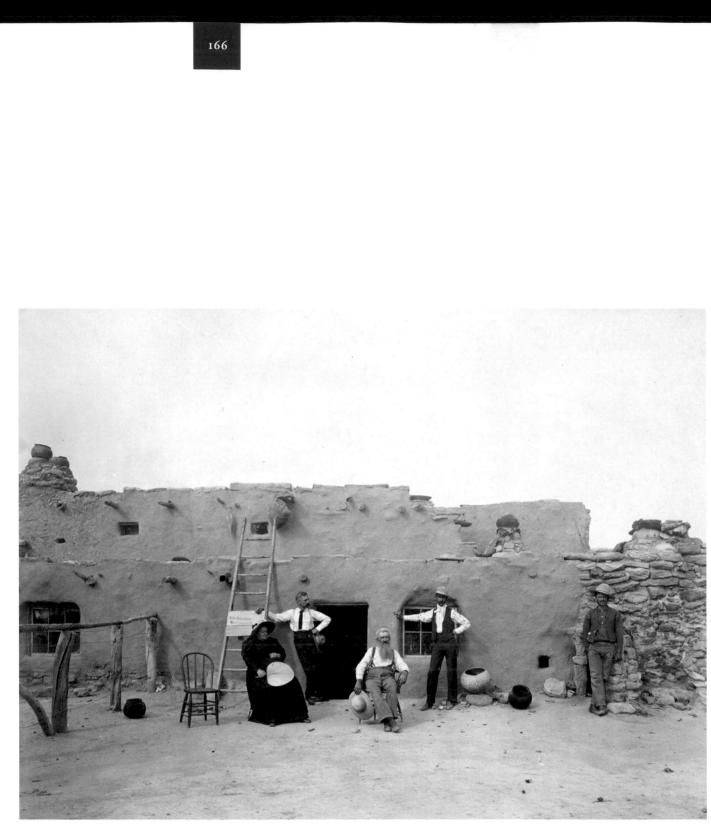

133 A. C. Vroman

Our Home on the Mesa

New Mexico

August, 1895

aristotype print

15.2 x 20.5 cm (6 x 8 1/16")

Vroman is the fourth person from

left to right.

134 Kolb Brothers

Tourists in the Grand Canyon

Arizona

circa 1910

silver print

25.4 x 20.3 cm (10 x 8")

The Kolb Brothers operated a studio
at the Grand Canyon around the turn
of the century.

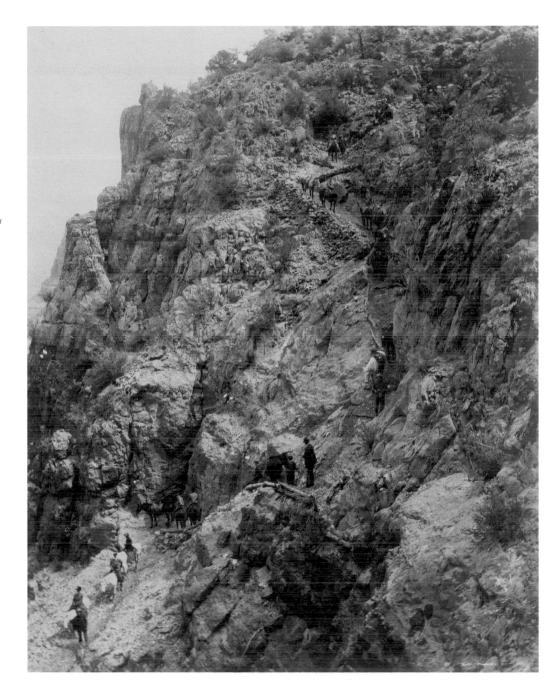

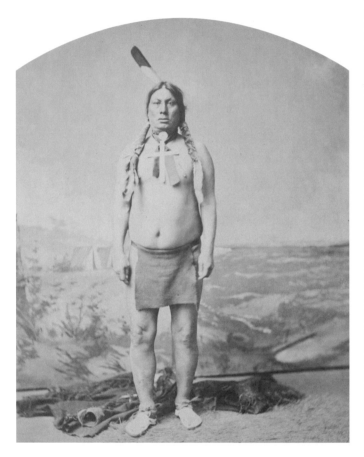

135a D. F. Barry

Chief Gall Standing

circa 1880s

albumen print

33.7 x 26 cm (13 ¼ x 10 ¼")

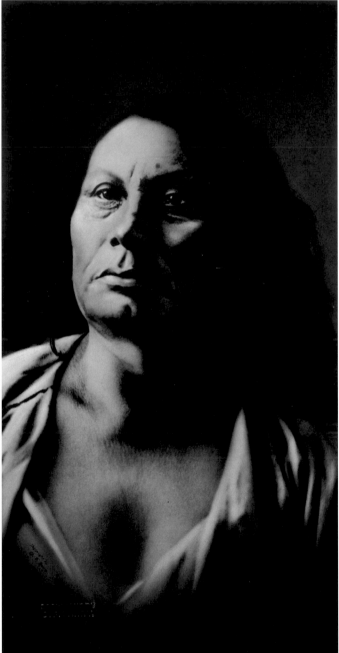

135b D. F. Barry

Chief Gall

circa 1880s, printed circa 1900

toned silver print

28.6 x 14.6 cm (11 ¼ x 5 ¾")

136 Issac Taber

Portrait of General Nelson Miles

San Francisco, California

circa 1895

albumen print

29.9 x 17.5 cm (11 ¾ x 6 ⅞")

Miles was the officer who gained
Geronimo's surrender. He shipped
Geronimo and the 37 survivors
from the Apache's band to Florida.

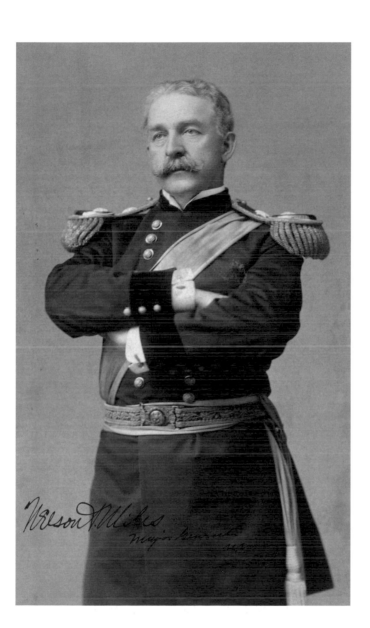

137 Camillus S. Fly

Tombstone, Arizona

Apaches Leaving Fort Bowie

for Florida

Arizona Territory

1886

albumen print

11.8 x 19.1 cm (4 ⅝ x 7 ½")

138 Edward S. Curtis

Vanishing Race

1904

platinum print

15.2 x 20.3 cm (6 x 8")

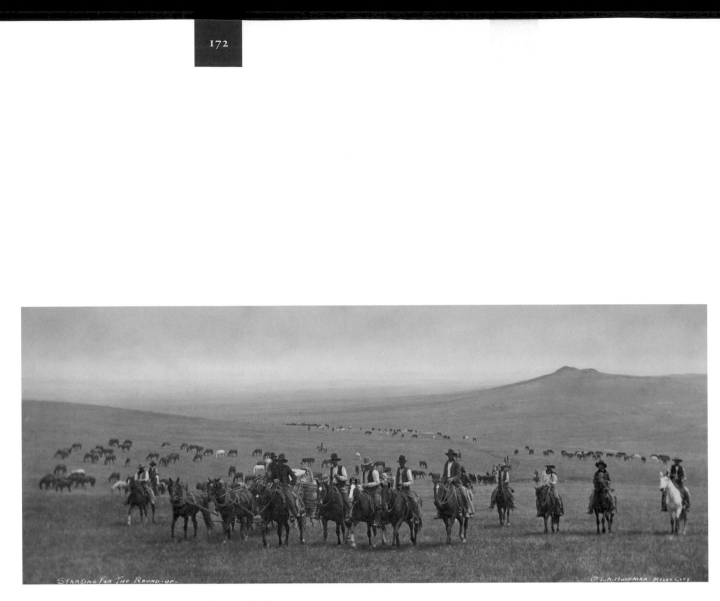

139 Laton A. Huffman

Starting for the Round-Up

Montana

circa 1900

panorama hand-colored silver print

25.4 x 59.7 cm (10 x 23 ½")

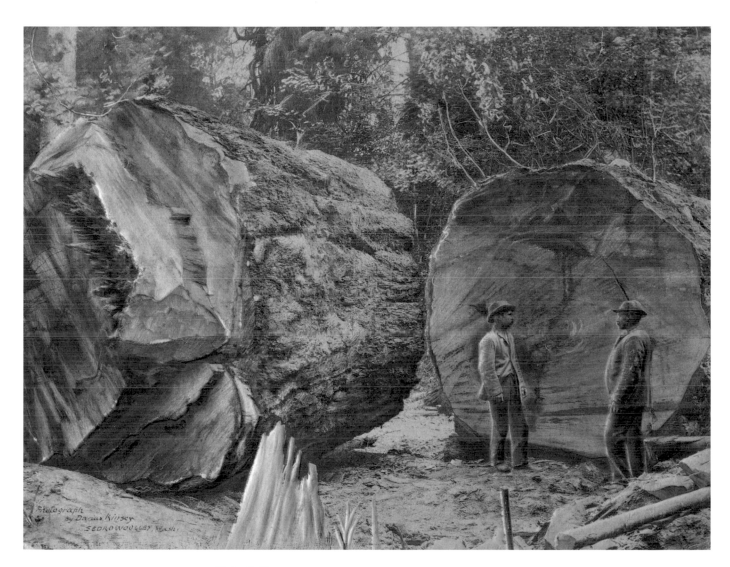

140 Darius B. Kinsey

Two Loggers

Washington State

circa 1910

bas-relief silver print

17.2 x 22.9 cm (6 ¾ x 9")

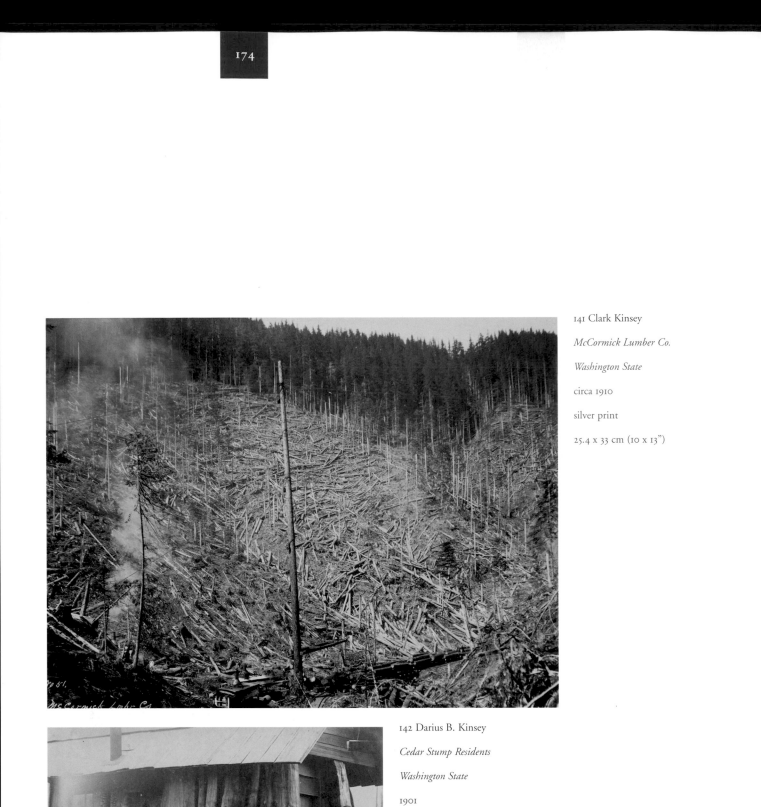

141 Clark Kinsey

McCormick Lumber Co.

Washington State

circa 1910

silver print

25.4 x 33 cm (10 x 13")

142 Darius B. Kinsey

Cedar Stump Residents

Washington State

1901

toned silver print

15.2 x 20.3 cm (6 x 8")

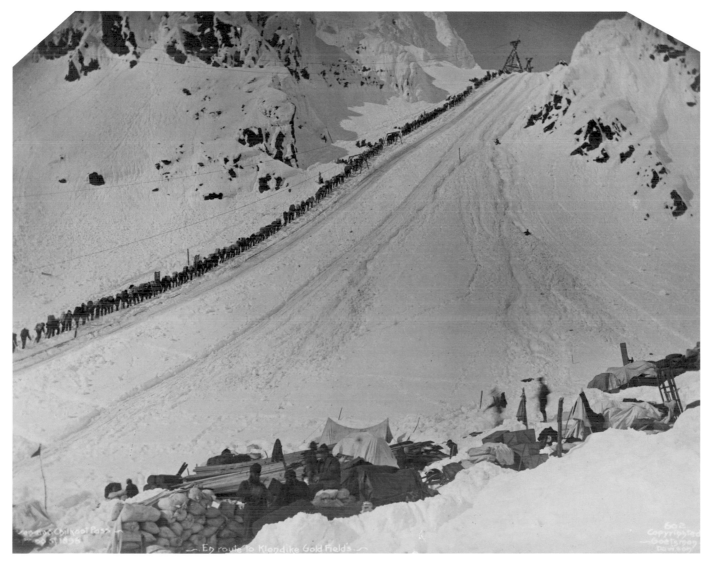

143 H. J. Goetzman

Climbing Chilkoot Pass

circa 1900, printed circa 1920

silver print

41.3 x 51.4 cm (16 ¼ x 20 ¼")

144 Unidentified

Mine Workers

Western United States

circa 1900

platinum print

21 x 16.5 cm (8 ¼ x 6 ½")

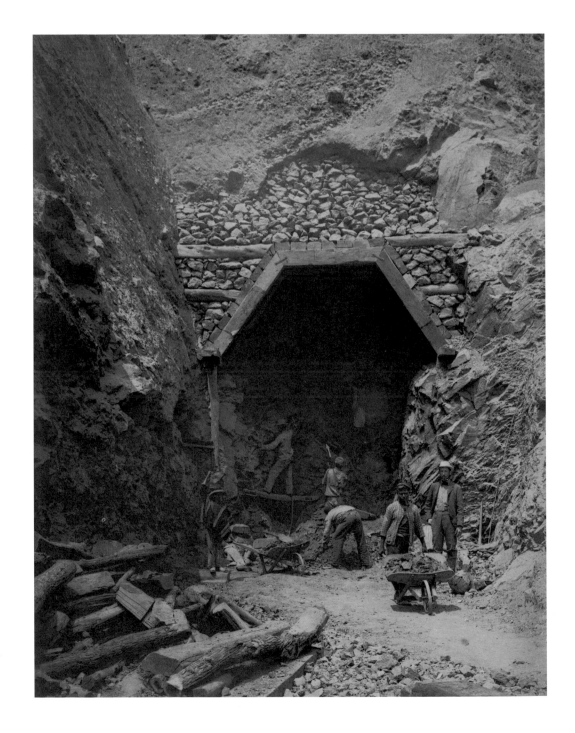

145 Percival C. Armitage

Hot Number Tunnel

Prescott, Arizona

1907

toned silver print

45.7 x 55.9 cm (18 x 22")

In addition to taking photographs,
Armitage sold picture frames, art goods,
stationery and office supplies.

146 William Savage

Scofield Mining Disaster

(Dead Miners in Schoolhouse)

Utah

1900

silver print

15.2 x 20 cm (6 x 7 ⅞")

147a Vader

Constructing Church of Christ

Tabernacle, "Ready to Begin, 8:00 am"

Clarkston, Washington

circa 1900

silver print

10.2 x 23.5 cm (4 x 9 ¼")

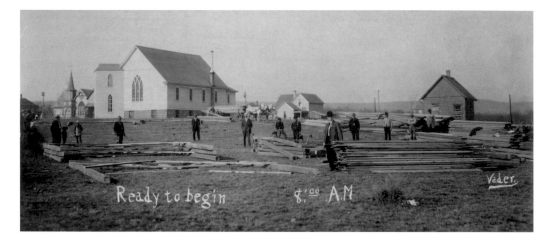

147b Vader

Constructing Church of Christ

Tabernacle, "Noon"

Clarkston, Washington

circa 1900

silver print

10.2 x 23.5 cm (4 x 9 ¼")

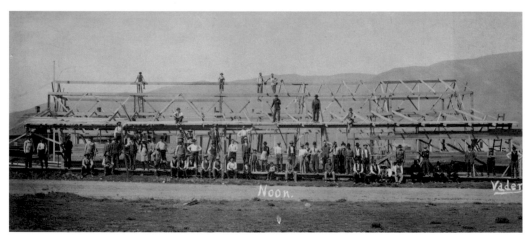

147c Vader

Constructing Church of Christ

Tabernacle, "Erected in One Day"

Clarkston, Washington

circa 1900

silver print

10.2 x 23.5 cm (4 x 9 ¼")

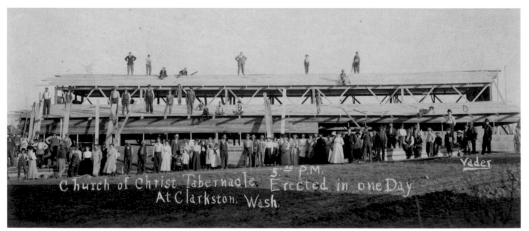

148, 1-10 Unidentified

Tornado at Baxter Springs

Kansas

1895

albumen prints, 10 on mount

24.1 x 19.7 cm (9 ½ x 7 ¾")

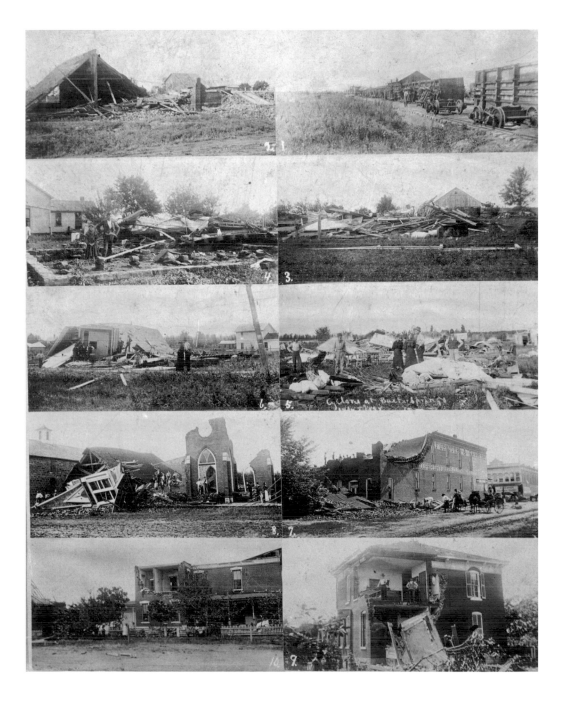

149 Fred Holomboe

Wolf Family Farm

Turtle Creek, North Dakota

1920

toned silver print

12.7 x 17.8 cm (5 x 7")

Holomboe was the staff photographer

for the Bismarck Tribune.

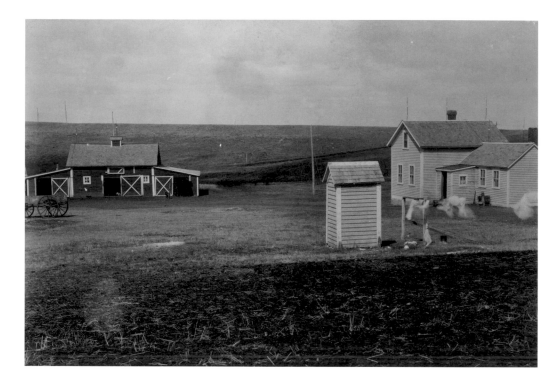

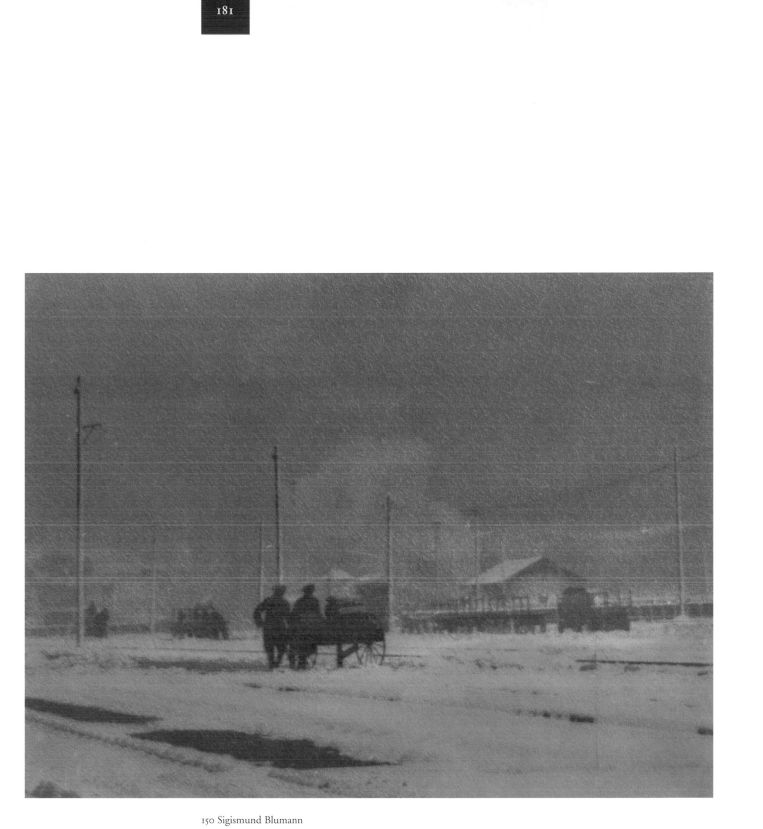

150 Sigismund Blumann

Winter at the Station

circa 1930

lithobrome print

19.1 x 24.1 cm (7 ½ x 9 ½")

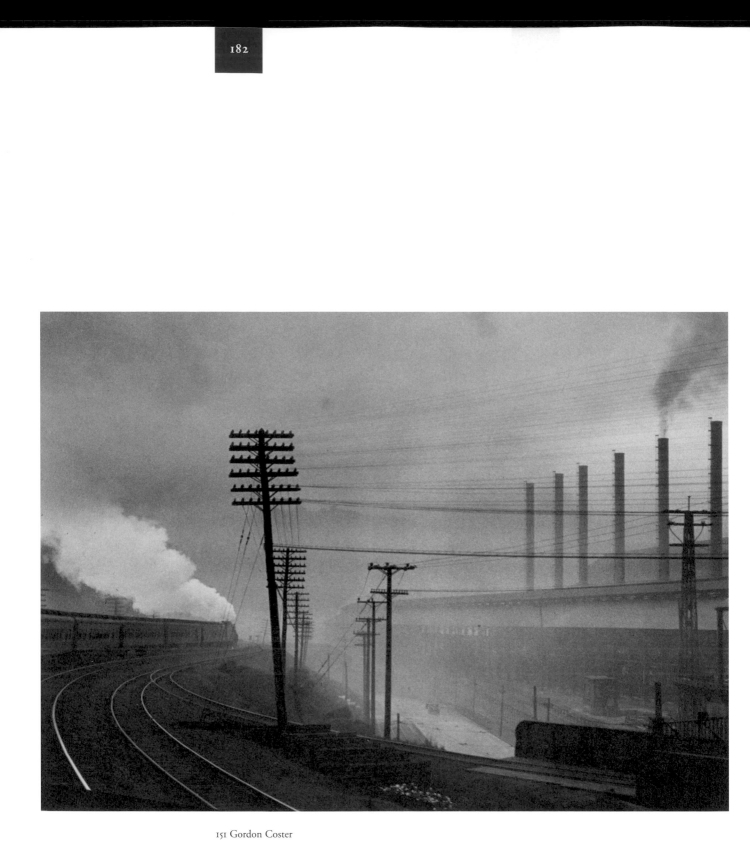

151 Gordon Coster

Passing through Pittsburgh

Pennsylvania

circa 1930

bromide print

24. x 34.3 cm (9 ¾ x 13 ½")

152 Pettus Kaufman

Train Detail

circa 1935

silver print

27.9 x 35.6 cm (11 x 14")

153 Unidentified

Langley Airplane Model

Virginia

1901

silver print

27.9 x 35.6 cm (11 x 14")

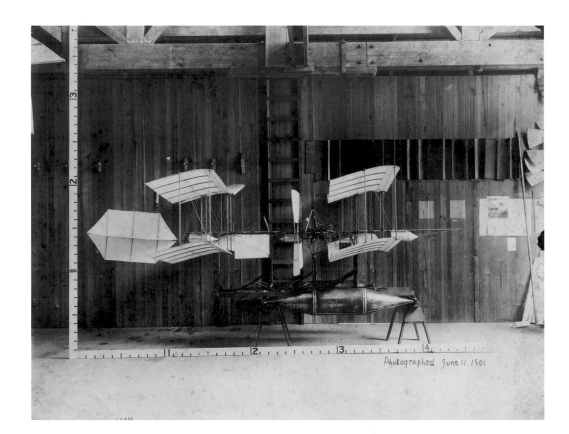

154 James Doolittle

United Airlines Night Flight

circa 1938

silver print

35.6 x 27.9 cm (14 x 11")

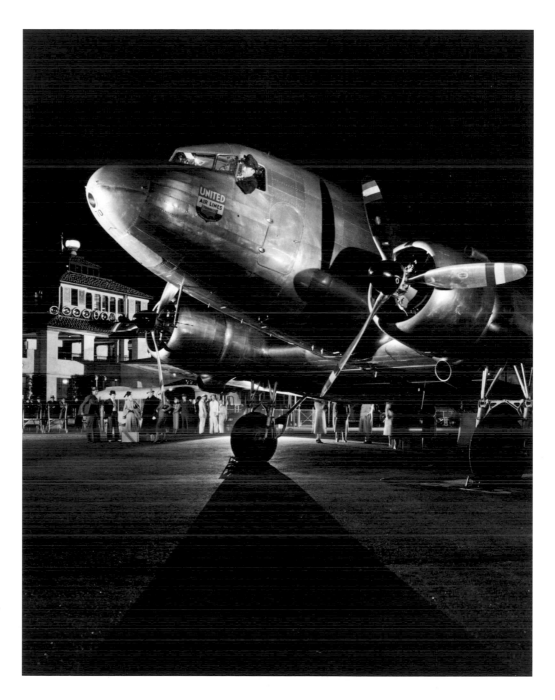

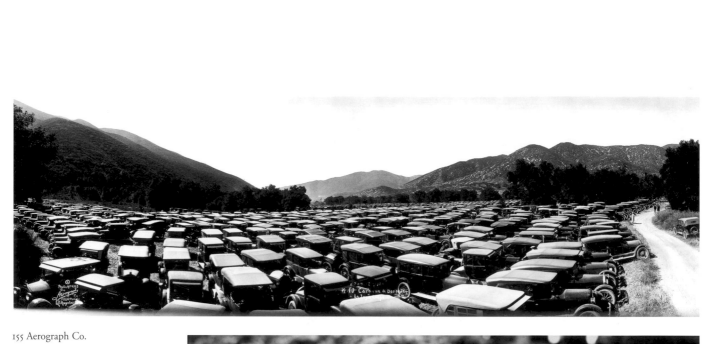

155 Aerograph Co.

Radio Station KHJ *Caravan*

and Barbecue

Topanga, California,

1924

silver print

25.4 x 72.4 cm (10 x 28 ½")

156 E. Mason

Automobile Engine of Mercedes

circa 1915

silver print

19.1 x 24.1 cm (7 ½ x 9 1/5")

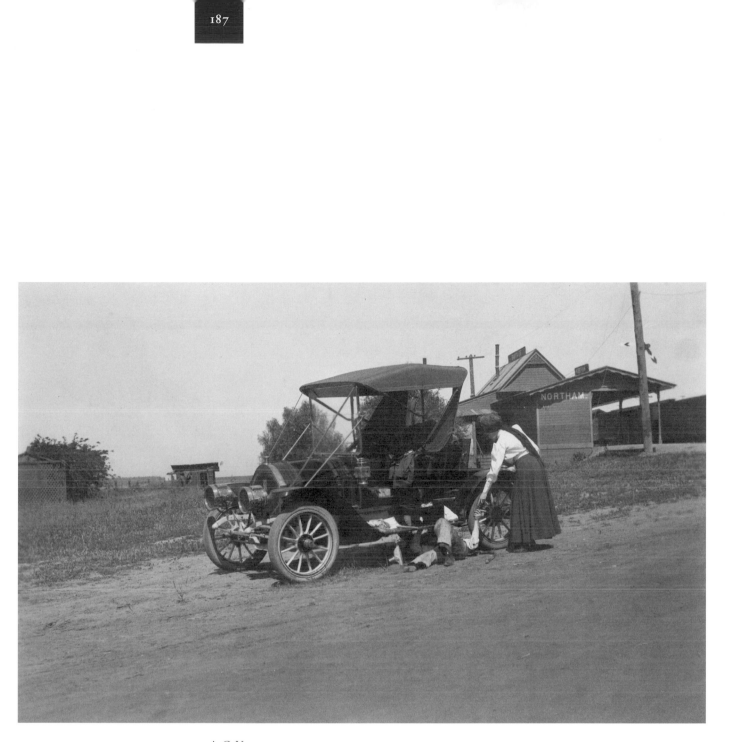

157 A. C. Vroman

Trouble on the Way

to Capistrano Mission

California

1909

platinum print

10.2 x 15.9 cm (4 x 6 ¼")

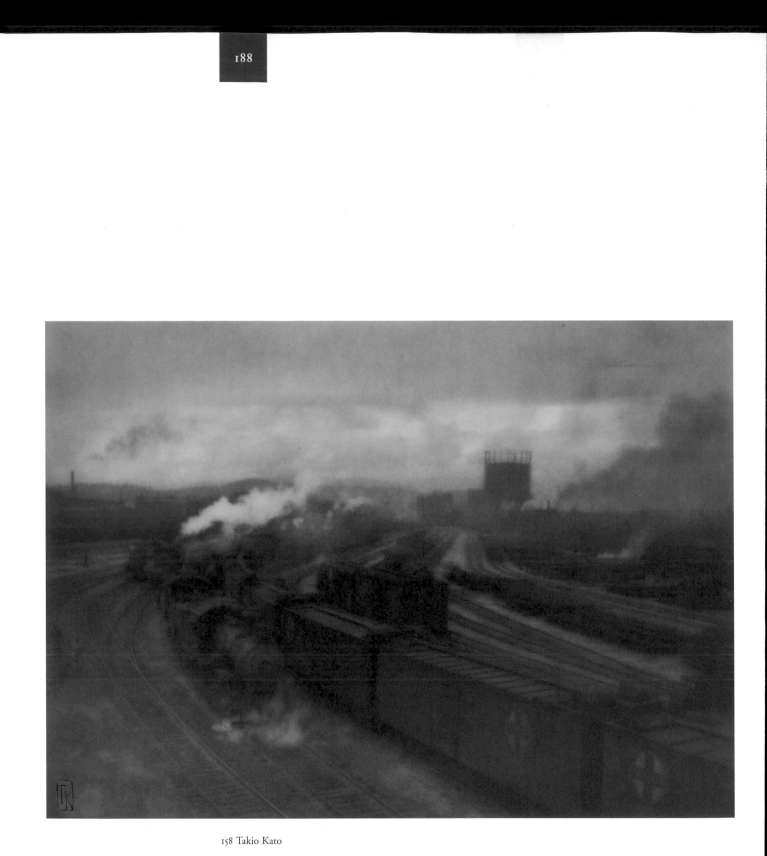

158 Takio Kato

Union Station Trains

Los Angeles, California

circa 1920

bromide print

25.4 x 34.3 cm (10 x 13 ½")

159 Unidentified

View of Hollywoodland

Los Angeles, California

circa 1924

silver print

27.9 x 35.6 cm (11 x 14")

160 Unidentified

Night View of Los Angeles

from Hollywoodland

California

circa 1924

silver print

27.9 x 35.6 (11 x 14")

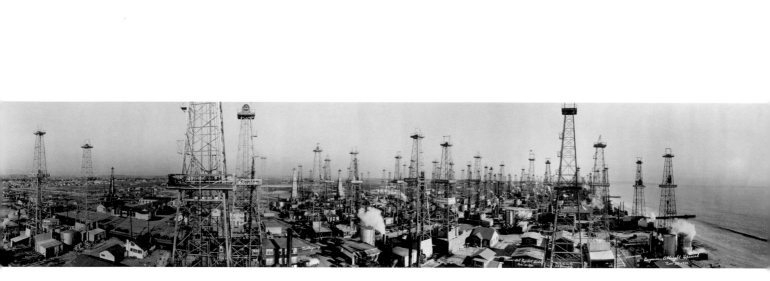

161 C. C. Pierce

Venice Del Rey Oil Field

California

1930

panorama silver print

25.4 x 110.5 cm (10 x 43 ½")

162 Will Connell

Building Wings in Douglas

Aircraft Factory

Santa Monica, California

circa 1936, printed 1950s

silver print

48.9 x 38.1 cm (19 ¼ x 15")

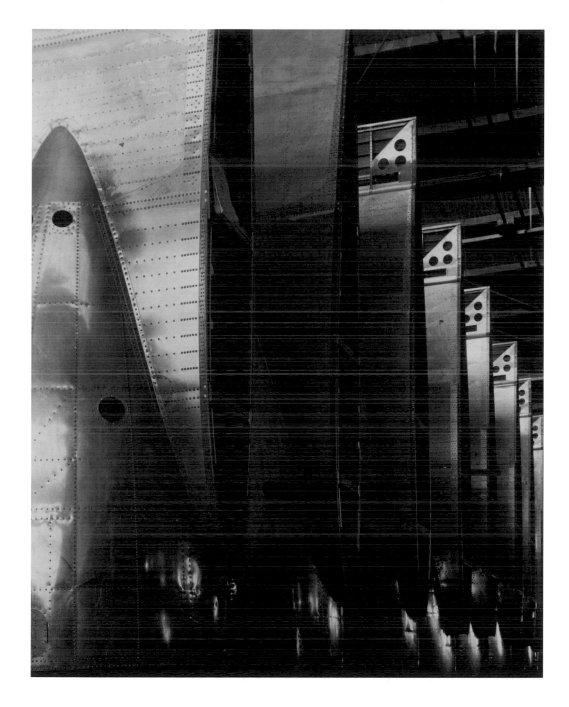

THE CITY
RISES

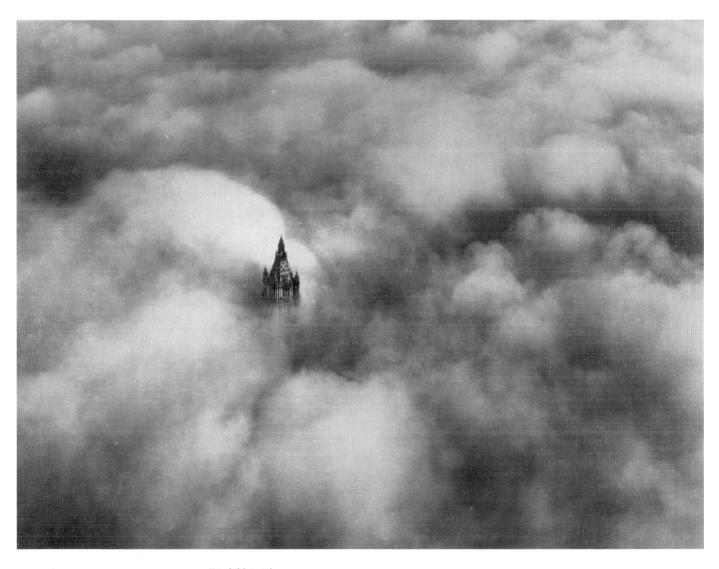

163 Fairchild Aerials

Woolworth Building in Clouds

New York City

circa 1930

silver print

16.8 x 22.2 cm (6 ⅝ x 8 ¾")

When first setting eyes upon New York City, Charles Dickens said that there lay stretched a confused heaps of buildings, with here and there a spire or steeple, looking down upon the herd below; and here and there again a cloud of lazy smoke.

New York, surrounded on both sides by rivers, close to the Atlantic shore, served as a major port. John Johnston, a chronicler of New York in the late 19th-century, photographed the thriving shipping center from the Brooklyn Bridge soon after its construction in 1883 (pl.165). In her examination of the ever changing New York cityscape, Berenice Abbott used the rigging of a sailing ship to frame the Manhattan skyline in the background (pl.164).

In the beginning of the 20th-century, New York City seemed the focal point of every immigrant dream and aspiration. Despite deplorable living conditions, leaving many hapless souls as fodder for medical dissections (pl.176), the population kept swelling in size. New immigrants, replacing old immigrants, served as a bottomless supply of cheap labor in sweat shops and factories. Alfred Stieglitz needed only a small three-by-four inch image to display the conditions of city life: the crowd of commuters, the ferry, and the factories belching a smoky greeting from across the river (pl.181). To escape the filth, the heat and the smells of the city, commuters would, one hundred years ago, head for early housing developments like this one on Long Island (pl.182).

Across America, rising metropolises offered great pictorial opportunities for photographers. Cities, like Washington D.C., rose out of the swamp (pl.167). They hugged the eastern shoreline, and they flourished beside the great lakes and along the mighty rivers that wove through the heartland. C. E. Bunnell stood in the middle of a Chicago street, one early morning in 1912, to take a photograph of his great midwestern city (pl.168). W. Gray's photograph of the Stewart House in New York City appears, on the other hand, like a cover for a tame Henry James novel (pl.175).

Years earlier, in 1877, Eadweard Muybridge climbed onto the highest point of the Mark Hopkins Mansion to take a magnificent panorama of the entire city of San Francisco. A slightly reduced 20th-century copy of the original mammoth size panorama shows the magnitude of Muybridge's undertaking (pl.170). Some thirty years later, a Chicago photographer, George Lawrence took a different panorama of San Francisco. While standing on the ground, he triggered his panoramic camera mounted on a tethered balloon 800 feet off the ground with a remote device to show the devastation caused by the 1906 earthquake (pl.171).

Wars, fires, and disasters such as the gas explosion in downtown Boston in 1897 (pl.178a-c) took their toll on our cities. However, wrecking balls could take down buildings faster than most natural calamities (pl.174). In the blink of an eye, new construction followed demolition (pl.173). What had been the New York tombs became the New York Public Library. In 1912, Karl Struss took a photograph of Fifth Avenue in front of the new library (pl.180). It took an aerial photograph by the Fairchild Company to capture the Woolworth Building above the dense clouds (pl.163), and the Empire State Building, the tallest building of its day, emerged magnificent and straight, piercing the clear sky, after a mere few months of construction (pl.172a-j).

No one portrayed the city better than John Albok. An immigrant tailor by trade, he was an amateur photographer expressing his deep appreciation for his new world. In this final exhibition photograph, taken during the depression, Albok turned his camera toward the New York skyline in the direction of a depressed Wall Street. Cast in darkness, the city struggles on, while above the clouds promise us rays of sunshine and hope for the future (pl.183).

Like the herd below, city-dwellers live their lives among the confused heaps of buildings. We dreamers struggle through a lazy cloud of smoke to get to the good days lying just around the corner - no foolin'!

164 Berenice Abbott

Theoline, Pier 11, East River

Manhattan, New York

April 9, 1936, printed 40s?

silver print

43.2 x 35.6 cm (17 x 14")

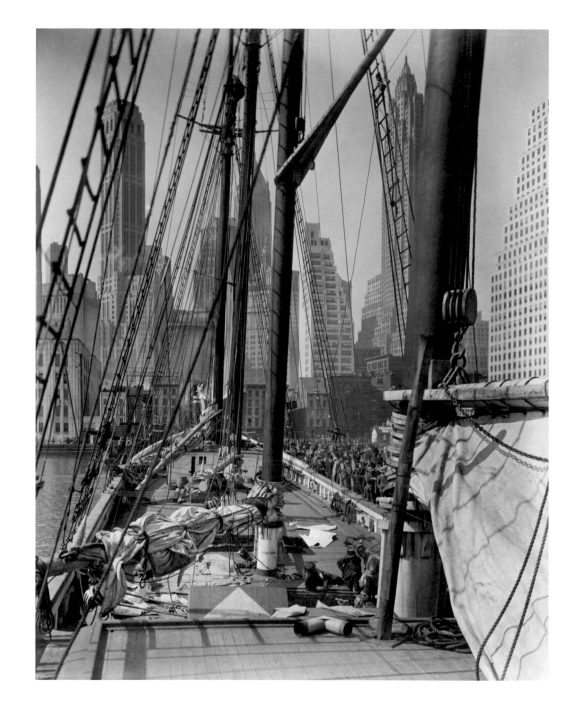

165 John S. Johnston

View from the Brooklyn Bridge

New York City

1894

albumen print

20.3 x 33.7 cm (8 x 13 ¼")

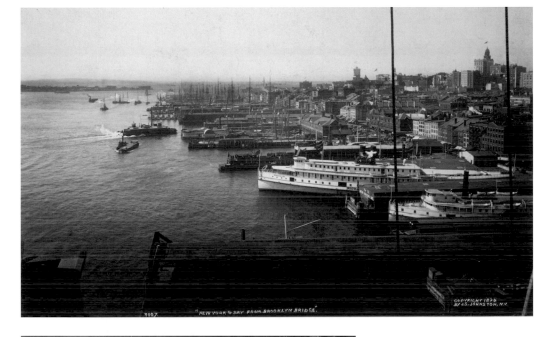

166 Arthur Leipzig

Produce Market, Early Morning

New York City

circa 1936

silver print

20.3 x 25.1 cm (8 x 9 ⅞")

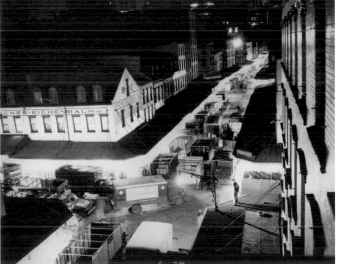

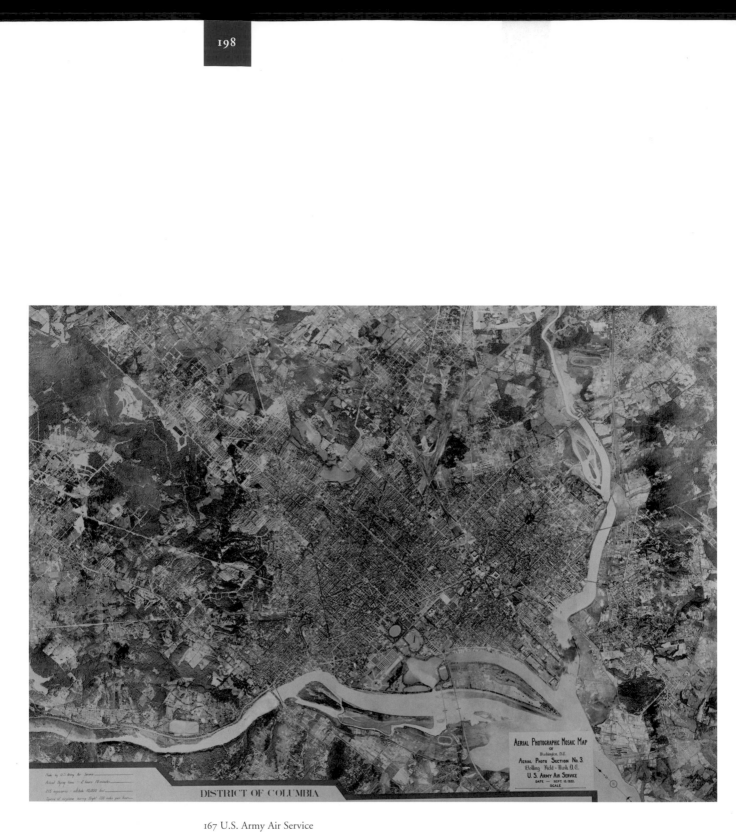

167 U.S. Army Air Service

Washington, District of Columbia

from 10,000 feet

1922

silver print

33.7 x 46.4 cm (13 ¼ x 18 ¼")

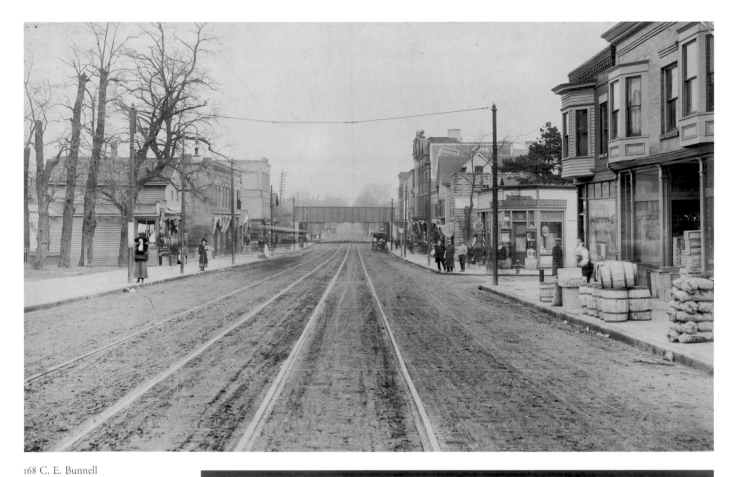

168 C. E. Bunnell

Camera on North St. in Center of

Northbound Track about 150 ft.

So. of Ontario St. Looking N.

Chicago, Illinois

December 14th, 1912

silver print

22.9 x 34.3 cm (9 x 13 ½")

169 William P. Mayfield

Parked Cars

Dayton, Ohio

1920

silver print

18.6 x 24.5 cm (7 5/16 x 9 ⅝")

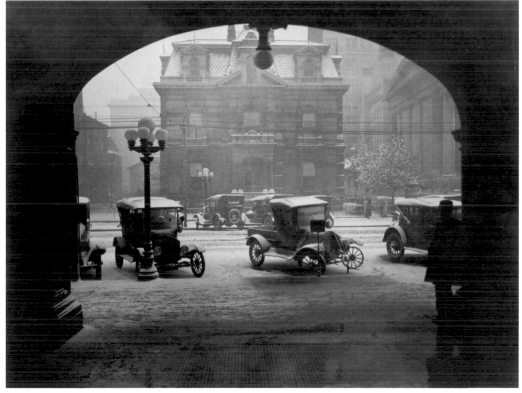

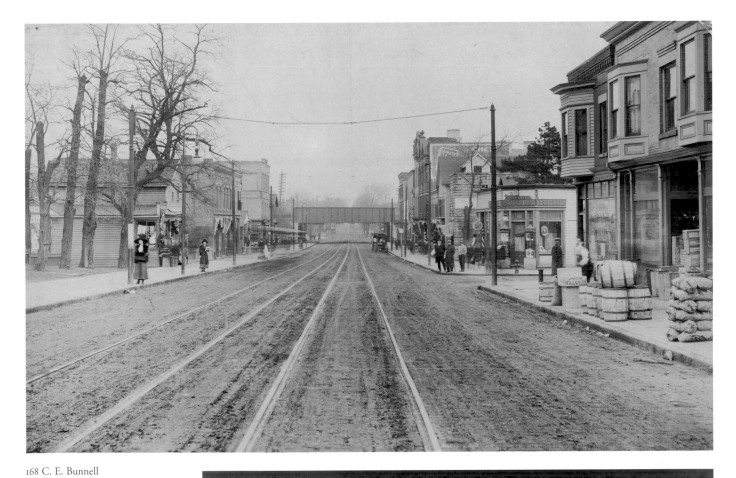

168 C. E. Bunnell

Camera on North St. in Center of

Northbound Track about 150 ft.

So. of Ontario St. Looking N.

Chicago, Illinois

December 14th, 1912

silver print

22.9 x 34.3 cm (9 x 13 ½")

169 William P. Mayfield

Parked Cars

Dayton, Ohio

1920

silver print

18.6 x 24.5 cm (7 5/16 x 9 ⅝")

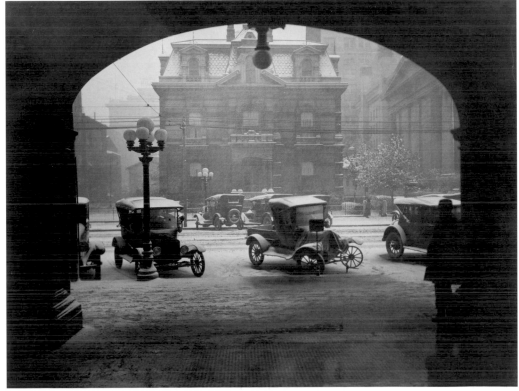

170 Eadweard Muybridge

Panorama of San Francisco, California

Copied from 1878 panorama,

circa 1950

toned silver prints

13 panels, each 46.7 x 36.8 cm

(18 ⅜ x 14 ½")

total size 607.1 x 478.4

(238 ⅞ x 188 ½")

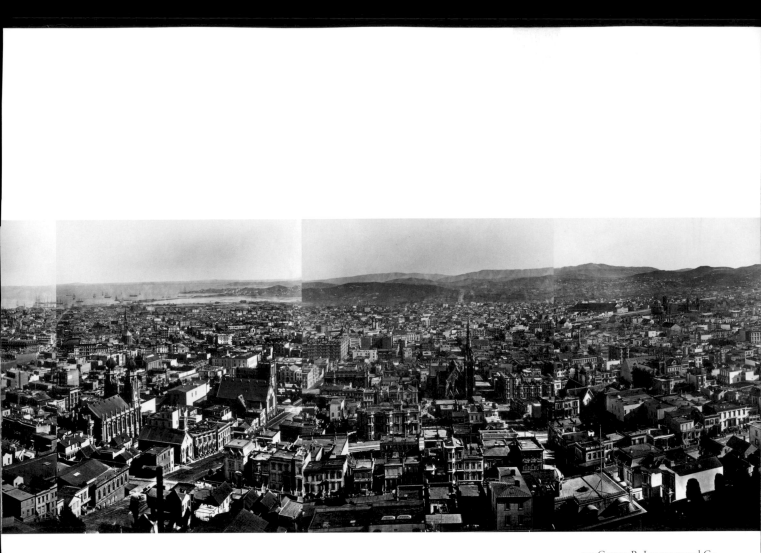

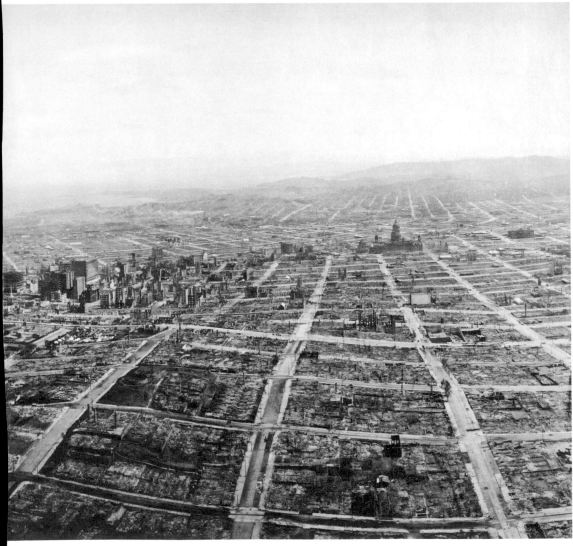

171 George R. Lawrence and Co.

View of Earthquake Destruction

from a Captive Airship

San Francisco, California

May 29, 1906

photogravure print

40.6 x 96.5 (16 x 38")

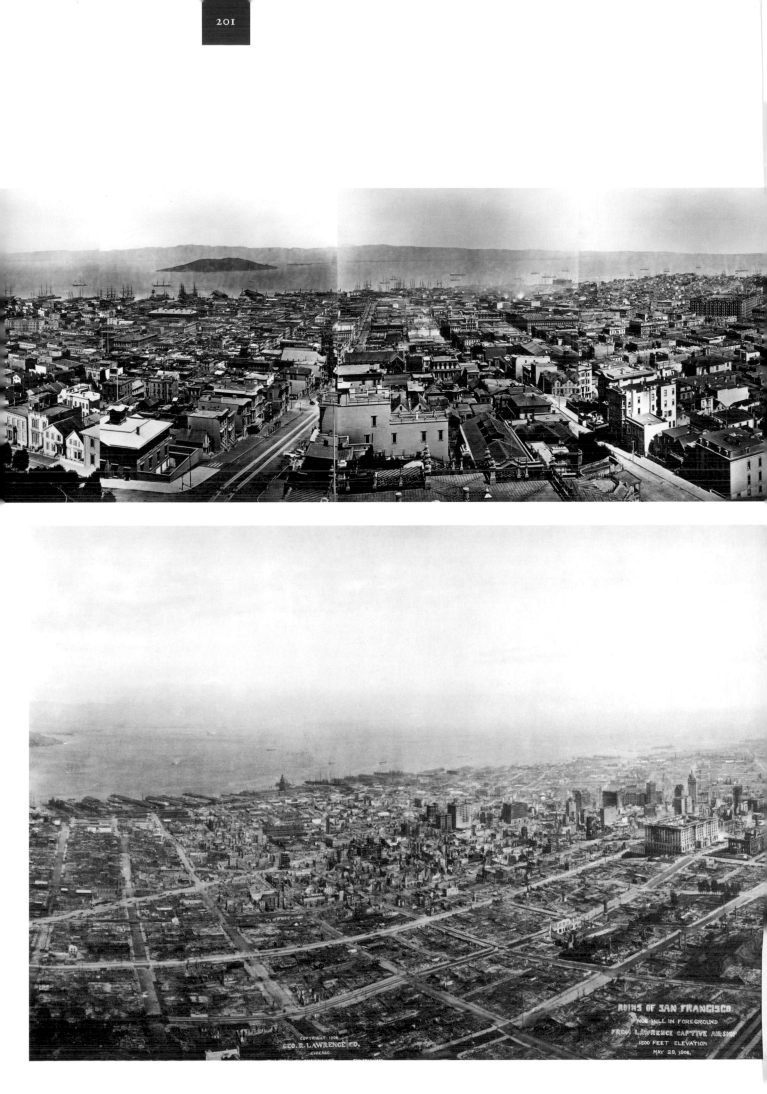

RUINS OF SAN FRANCISCO
NOB HILL IN FOREGROUND
FROM LAWRENCE CAPTIVE AIRSHIP
1500 FEET ELEVATION
MAY 29, 1906.

COPYRIGHT 1906
GEO. R. LAWRENCE CO.
CHICAGO.

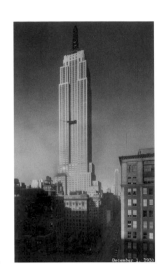

i

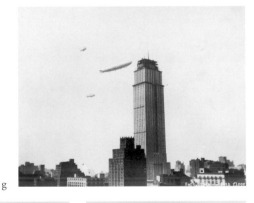

g

d

e

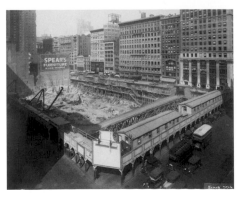

a

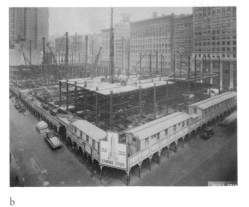

b

172a-j Knickerbocker Photo Service

Construction of Empire State Building

New York City

April-November, 1930

10 silver prints

each 29.2 x 20.3 cm (11 ½ x 8")

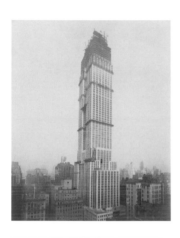

h

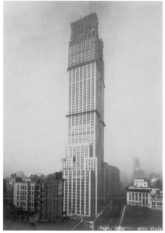

f

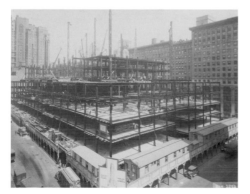

c

j

173 Unidentified

Caisson Work at

German-American Insurance Co.

New York City

1907

toned silver print

20.6 x 25.4 cm (8 1/16 x 10")

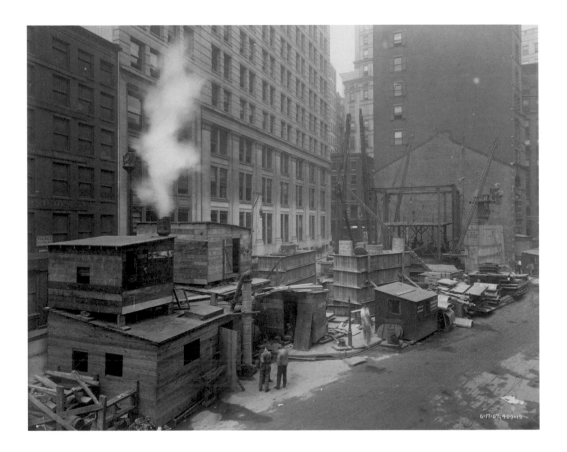

174 Shipley Brothers

The Wreckers

Salt Lake City, Utah

1909

silver print

19.1 x 24.1 (7 ½ x 9 ½")

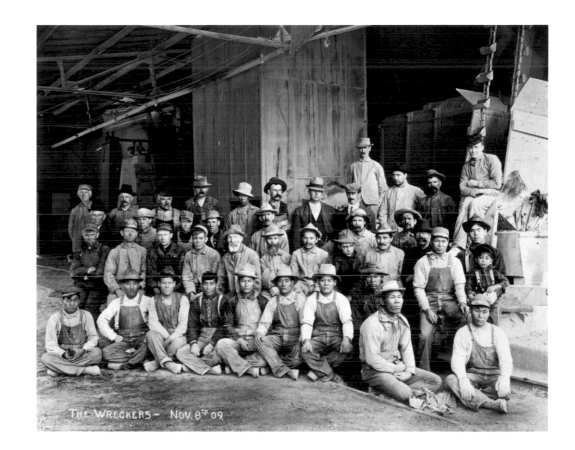

175 W. Gray

The Stewart Mansion

New York City

circa 1889

albumen print

16.2 x 23.5 cm (6 ⅜ x 9 ¼")

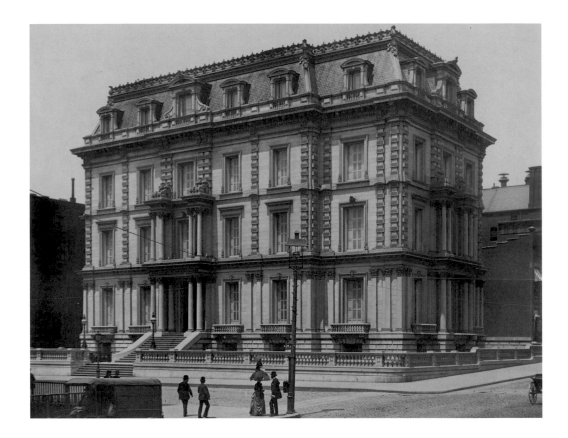

176 Unidentified

Dissection Room in a Medical School

New York City

circa 1910

platinum print

19.7 x 24.8 (7 ¾ x 9 ¾")

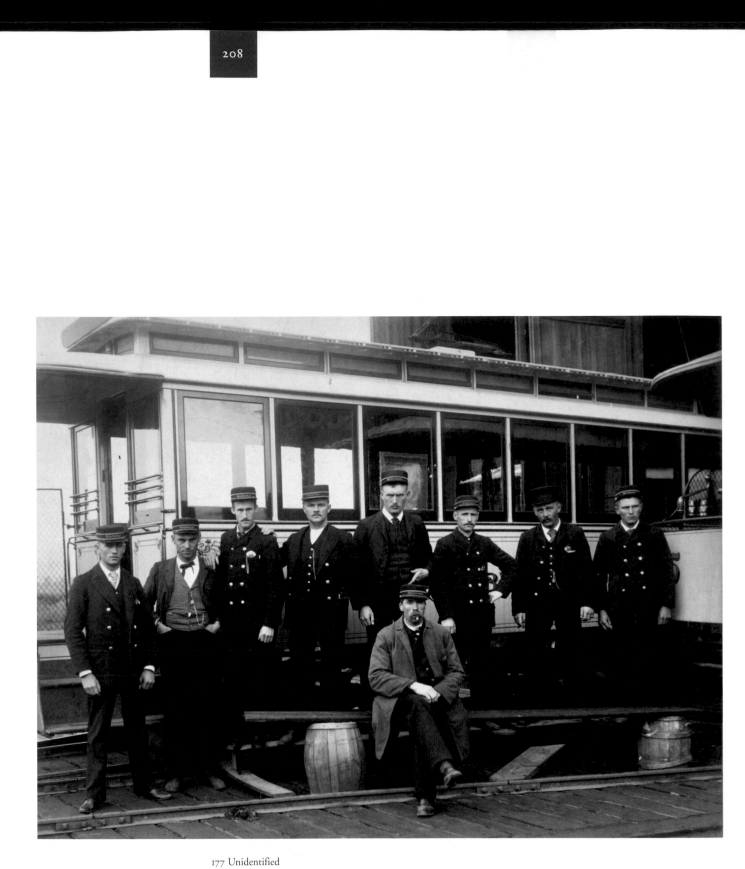

177 Unidentified

Trolley Conductors

Oakland, California

circa 1880

albumen print

18.1 x 24.1 cm (7 ⅛ x 9 ½")

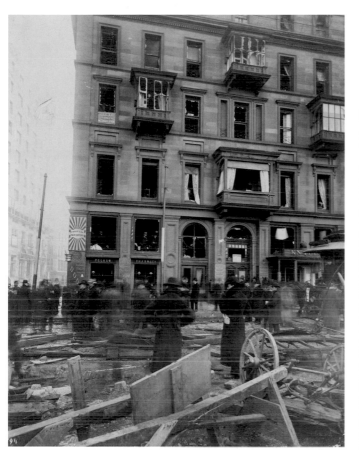

a

b

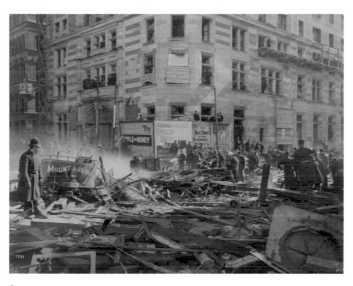

c

178a-c Nathaniel L. Stebbins

Gas Explosion at the Corner

of Tremont and Boylston Street

Boston, Massachusetts

1897

aristotype prints

top left, 24.1 x 18.7 cm

(9 ½ x 7 ⅜")

top right, 18.4 x 18.4 cm

(7 ¼ x 7 ¼")

bottom, 19.1 x 24.1 cm (7 ½ x 9 ½")

Stebbins was best known for his

marine views. However, his studio

at 132 Boylston Street was close

enough to the disaster to allow

him to take these dramatic views

shortly after the explosion.

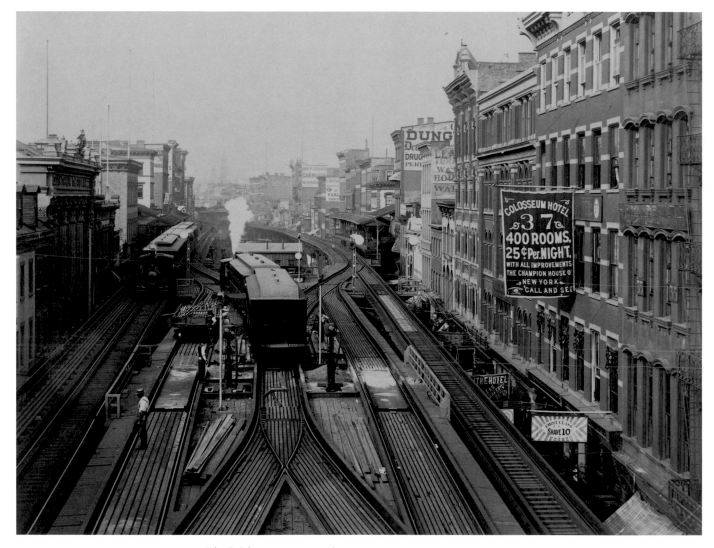

179 John S. Johnston

The Bowery from Chatham Street

New York City

1889

albumen print

15.9 x 21 cm (6 ¼ x 8 ¼")

180 Karl Struss

Fifth Avenue in front of the

New York Public Library

circa 1913

high key silver print

32.4 x 24.8 cm (12 ¾ x 9 ¾")

181 Alfred Stieglitz

Going Home by Ferry

New York City

circa 1902

silver print

9.2 x 11.8 cm (3 ⅝ x 4 ⅝")

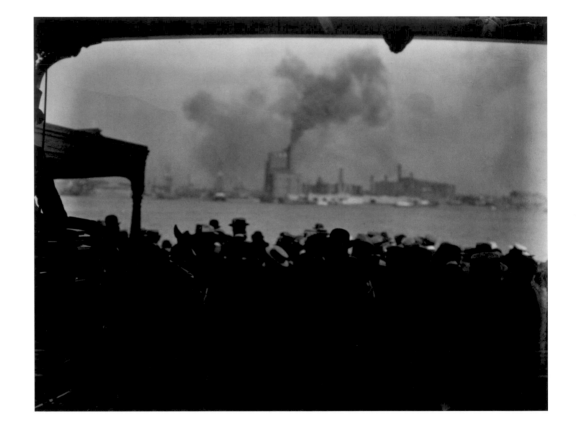

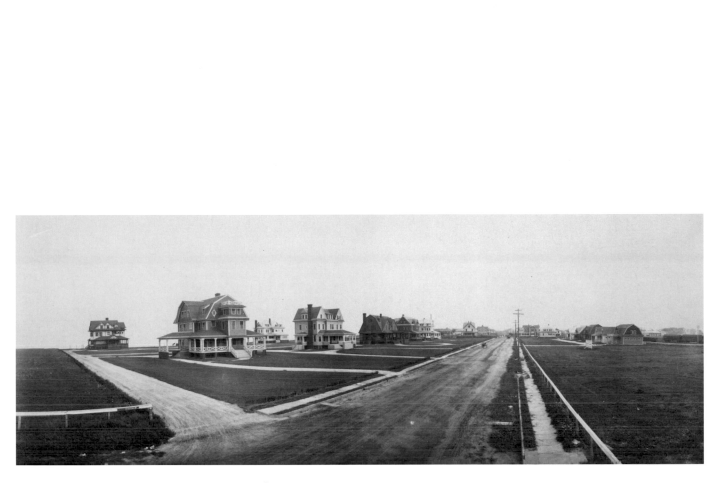

182 George P. Hall?

Real Estate Development

Long Island, New York

1900

silver print

11.4 x 30.5 cm (4 ½ x 12")

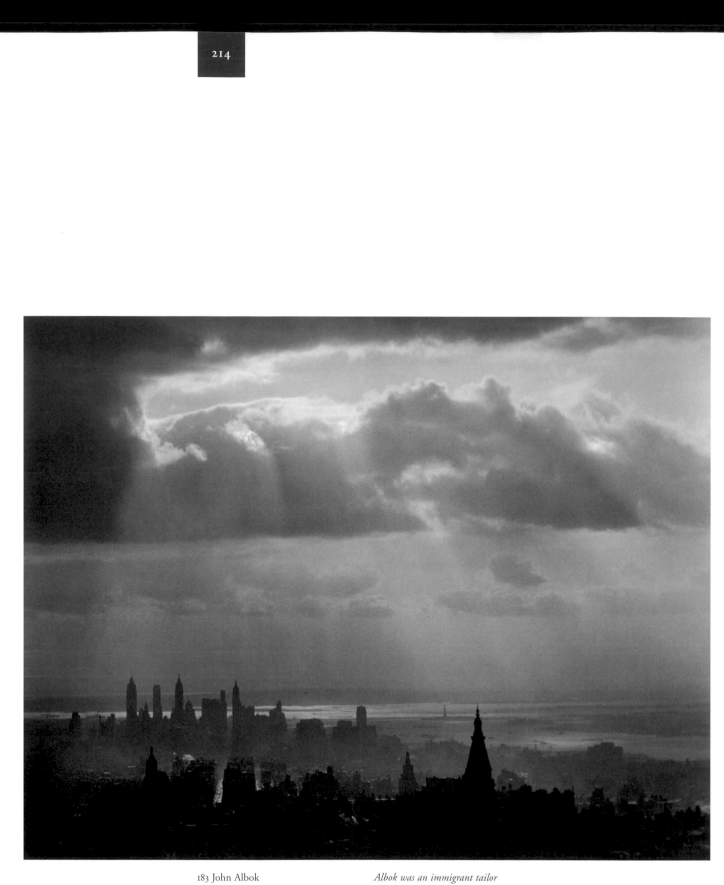

183 John Albok

Wall Street and Lower Manhattan

from the Chrysler Building

New York City

1933

silver print

35.6 x 44.5 cm (14 x 17 ½")

Albok was an immigrant tailor

as well as a prize-winning amateur

photographer.

INDEX

Proper Names*

When credited therein, illustrations in text (illus.), notes (n.), and plates (pl., pls.) follow the corresponding page numbers.

INDEX

Locations*

When credited therein, illustrations in text (illus.), notes (n.), and plates (pl., pls.) follow the corresponding page numbers.

Every effort was made to identify and contact all such parties to obtain official permission to reproduce, and we are very grateful for the kind cooperation extended by those involved. They are as follows: Commerce Graphics, East Rutherford, New Jersey for Berenice Abbott; Ilona Albok Vitarius, Dallas, Texas, for John Albok; Time Inc., New York, New York for Margaret Bourke-White; Howard Greenberg Gallery, New York for Anton Bruehl; The Imogen Cunningham Trust, Berkeley, California for Imogen Cunningham; Center for Creative Photograpy, University of Arizona, Tucson, Arizona for Adolf Fassbender and Hansel Mieth; G. Ray Hawkins Gallery, Santa Monica, California for Paul Outerbridge; Carousel Research, Inc., New York, New York for Edward Steichen.

Concept	Stephen White
Curators	Andreas Blühm and Stephen White
Translation	Rachel Esner
Editing	Rachel Esner and Mus White
Indexing	Mus White
Design	James Marrin and Dennis Reed
Layout	Stephen White
Production Consultant	Sue Medlicott
Production Supervisor	Erika Marrin
Printing	Calff & Meischke, Amsterdam
Color Separation	Salto, Belgium
Binding	Boekbinderij Van Waarden, Zaandam Hexspoor, Boxtel
Distribution	D. A. P. Distributed Art Publishers 155 Sixth Avenue, New York, NY 10013 www.artbook.com